LEVON AND KENNEDY

MISSISSIPPI INNOCENCE PROJECT

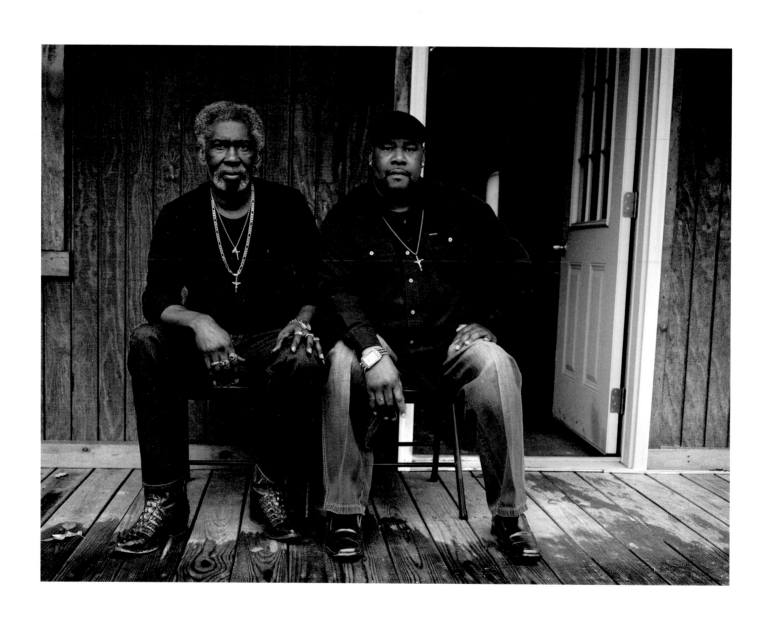

LEVON AND KENNEDY

MISSISSIPPI INNOCENCE PROJECT

———

Photographs by Isabelle Armand
Text by Tucker Carrington

powerHouse Books

Brooklyn, NY

MISSISSIPPI INNOCENCE: THE CONVICTIONS AND EXONERATIONS OF LEVON BROOKS AND KENNEDY BREWER AND THE FAILURE OF THE AMERICAN PROMISE

—

Tucker Carrington[1]

Part 1

The early spring day of March 25, 1995 dawned beautiful and fair in central east Mississippi. By noon, the temperature outside edged toward seventy degrees. The unseasonably warm weather was the last thing on Kennedy Brewer's mind though. Locked up in a cramped jail cell on the second floor of the county courthouse, he passed the time trying to ignore the things he could just barely get his mind around: the four years he had already spent behind bars waiting for a trial, his conviction for murder the day before, even the ill-fitting suit his lawyers had given him to wear. He prayed on the one thing he could not get his mind around: the fact that just down the hallway twelve jurors were deciding whether he should spend the rest of his life in prison for his crimes, or die for them.

Likely as not, Brewer was on a fast track to execution. The day before, the same jury had convicted him of the abduction, sexual assault, and murder of three-year-old Christine Jackson, his girl-friend's daughter. For the most part, Brewer's trial had been relatively uncomplicated and presented few thorny legal issues. From beginning to end it lasted just shy of two weeks. The prosecution's evidence was overwhelming. Brewer admitted to having been alone at home—a low-slung, mustard-colored clapboard house set a few feet off a rural gravel road—with the little girl in the hours immediately preceding her disappearance. Although he had always maintained that he had no idea what had happened to Christine—he claimed to have been sound asleep when she disappeared—he could offer no explanation about how someone could have gained entry into the house, much less access to the lone living space.

Then there were the bite marks—some nineteen in total—spread across her body. They matched precisely molds that law enforcement investigators had made of Brewer's teeth. According to the medical personnel who performed the autopsy and analysis, there were many more, but at a certain point it seemed fruitless to continue counting.

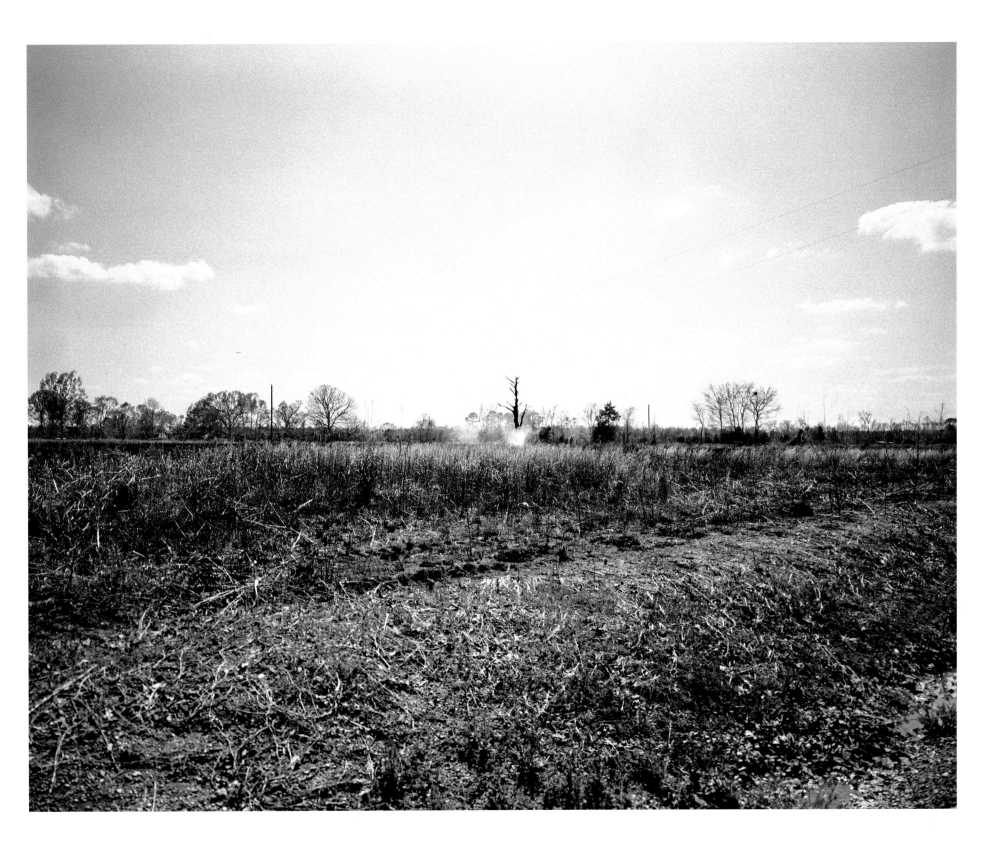

Fire Tower Road, Macon, Mississippi. Levon's neighborhood.

The second part of the trial—the penalty phase—had likewise been brief and not seriously contested. The facts of the case—a brutal sexual assault, manual strangling, and the disposal of Jackson's corpse in a creek, combined with whatever kind of savagery it took to cover her tiny body with bite marks—were by their very nature heinous, atrocious, and cruel: the factors that the State was obligated to prove in order to distinguish Brewer's crime from less egregious murders and earn a death sentence.

To make matters worse, there had been talk that this might not have been Brewer's first victim. Eighteen months earlier, another three-year-old girl had been raped and murdered only a few miles from Brewer's house. Like Christine Jackson, the first victim, Courtney Smith, had been sexually assaulted, manually strangled, and dumped into a small body of water. Law enforcement had arrested another local man for that crime—Levon Brooks—and he had been convicted and sentenced to a term of life imprisonment. However, the almost identical *modus operandi* in both cases led some to believe that Brewer was responsible for both homicides.

Brewer's defense attorneys also had little to present to the jury in the way of mitigation evidence—evidence that Brewer was deserving of something less than death. He showed no remorse, nor signs of mental retardation or other history of physical or mental illness. As for a childhood of abuse and neglect—frequently present in the lives of capital murder defendants and sometimes illustrative of vitiated culpability—there was none. In short, everything pointed to the seemingly inescapable conclusion that Brewer was a dissociative child killer who was eligible for the ultimate criminal sanction.

Brewer passed the early afternoon in his cell. Shortly before 2:00 p.m. those lingering in the courtroom heard a knock from the door leading to the jury deliberation room. The clerk walked to the door, cracked it slightly, and received a folded piece of paper. She read it quickly and then looked up. The jury had reached a unanimous decision. After sheriff's deputies ushered Brewer from his cell and back to his seat beside his lawyers, Judge Lee J. Howard returned to the bench and the clerk opened the rear door. The jurors filed in. They were solemn, their eyes averted from the defendant and his attorneys. Many had measured and drawn looks on their faces.

Judge Howard confirmed that they had in fact reached a unanimous verdict and then had the foreperson hand the verdict form to the deputy clerk so that it could be read into the record.

"We, the jury," the clerk read, "find that the defendant should suffer the penalty of death."

As the clerk's voice died away, Judge Howard ordered Brewer to enter the well of the courtroom. Brewer dutifully obeyed. Bracketed by

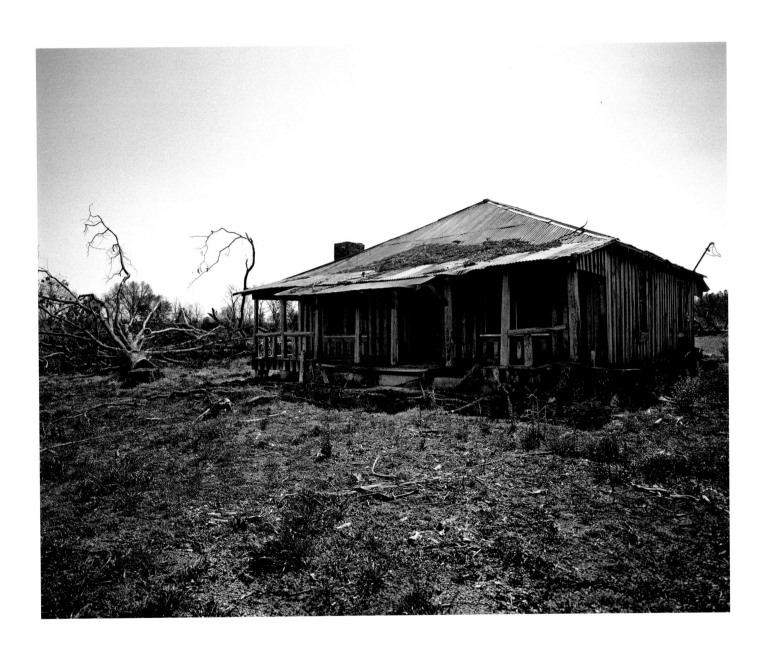

Levon was born in a similar house on the old plantation in Brooksville, Mississippi.

security personnel, he slowly stepped forward toward the bench.

"Mr. Brewer," Judge Howard said, "the jury of citizens of Lowndes County, Mississippi, has found you guilty of the crime of capital murder … The jury has returned that verdict in open court. That verdict was that you should suffer death. Do you have anything you desire to say to the Court before sentence is imposed?"

"No," Mr. Brewer responded softly.

I am by law required at this time to set a date for your execution …. I hereby direct that the sheriff immediately take custody of your body and immediately transport you to the maximum security unit of the Mississippi Department of Corrections at Parchman, Mississippi. You are to there remain in custody until May the twelfth of nineteen ninety-five, at which time you will be removed to a place where you shall suffer death by lethal injection. May God have mercy on your soul.

Guards ushered Brewer from court. With the jurors' work done, Judge Howard thanked them for their service and then formally dismissed them. It had been difficult work. The crime had been horrifying. Then there had been the trial, with its ineffably sad moments: the testimony about Christine, Brewer's mother's plea to spare her son's life while being forced by the prosecutor to admit that since his arrest there had not been another three-year old child sexually assaulted, killed, and dumped in the creeks of Noxubee County.

But there did seem to be something hopeful—if that was the right word—about the trial's end. What with their work done, and seemingly done well, and several hours still remaining in the lovely spring afternoon, it did not seem unreasonable to perceive some promise of a new and better season. As the jurors gathered their belongings—some speaking quietly together others choosing to remain alone with their thoughts—they walked down the short flight of stairs and out into the daylight.

Brewer, meanwhile, was already en route to Parchman Penitentiary, where he was fitted with a red jumpsuit and led to a small cell—number 285—in the heart of Maximum Security Unit 32, popularly known as "Death Row." He faced a bleak future of once-a-week showers, one hour per day of solitary recreation, and a looming execution date. Levon Brooks, Courtney Smith's convicted killer, was also housed in Parchman, across the prison grounds in a separate unit, finishing year four of his life sentence. According to actuarial tables for incarcerated prisoners, Brooks would age in prison twice as quickly as he would have on the outside, and be dead in approximately thirty years.

And that would have been that. Except for one thing: Kennedy Brewer and Levon Brooks were both innocent.

Jeremy, Levon's grandson, at the plantation where his grandfather was born.

LEVON BROOKS

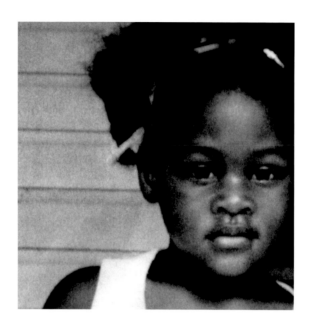

Courtney Smith (1986–1990). Her body was found in this pond in downtown Brooksville.

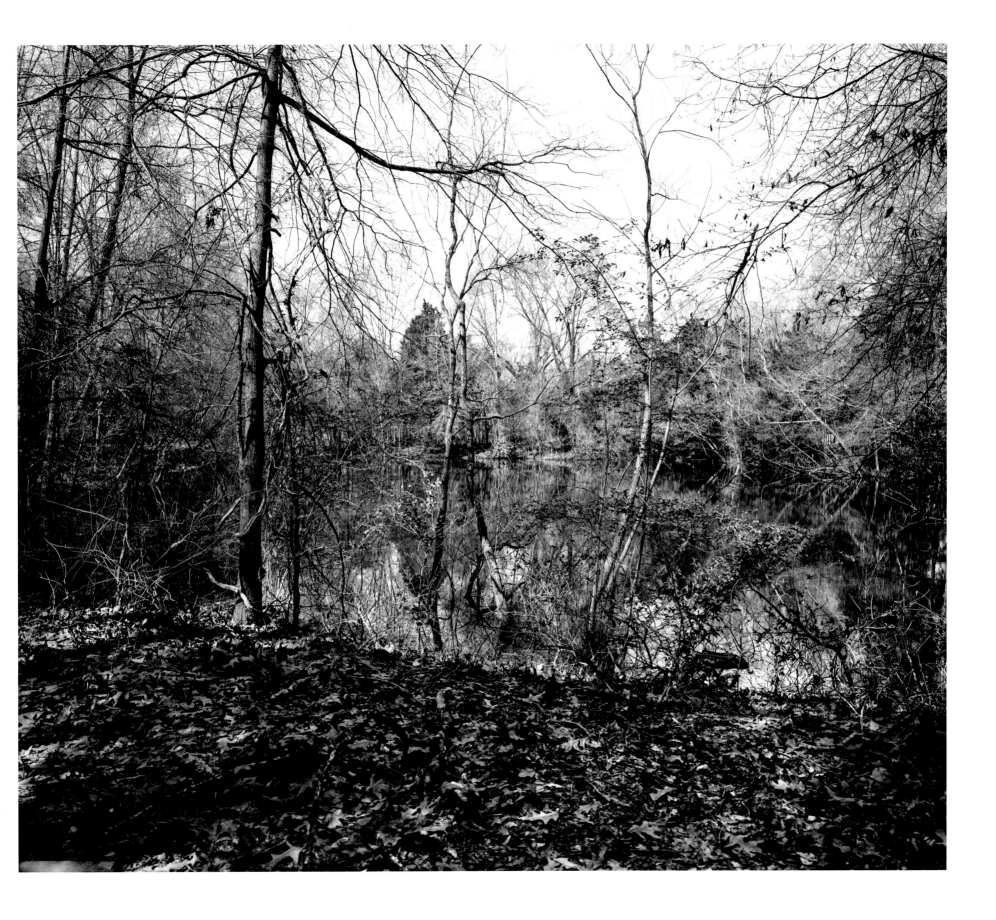

14

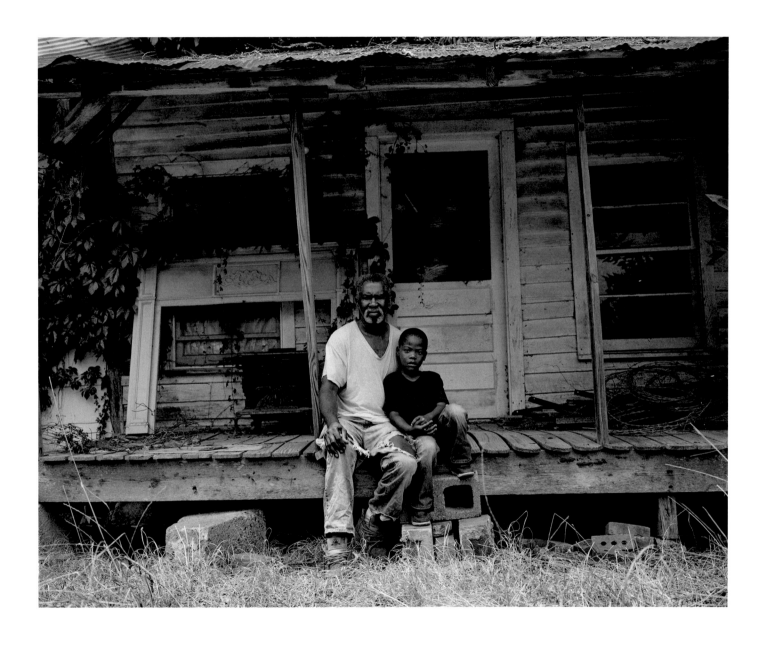

Levon and Jeremy at the plantation's old office.

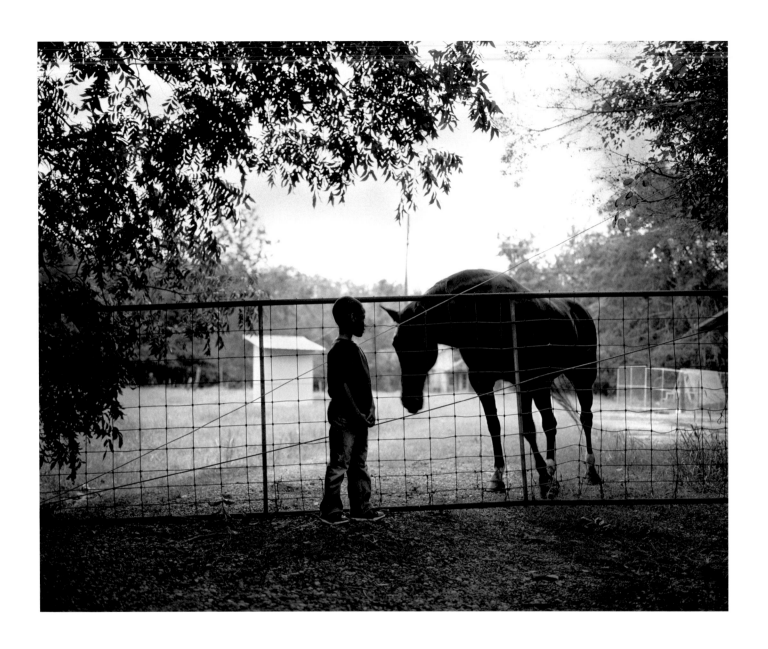

Jeremy and horse at the plantation.

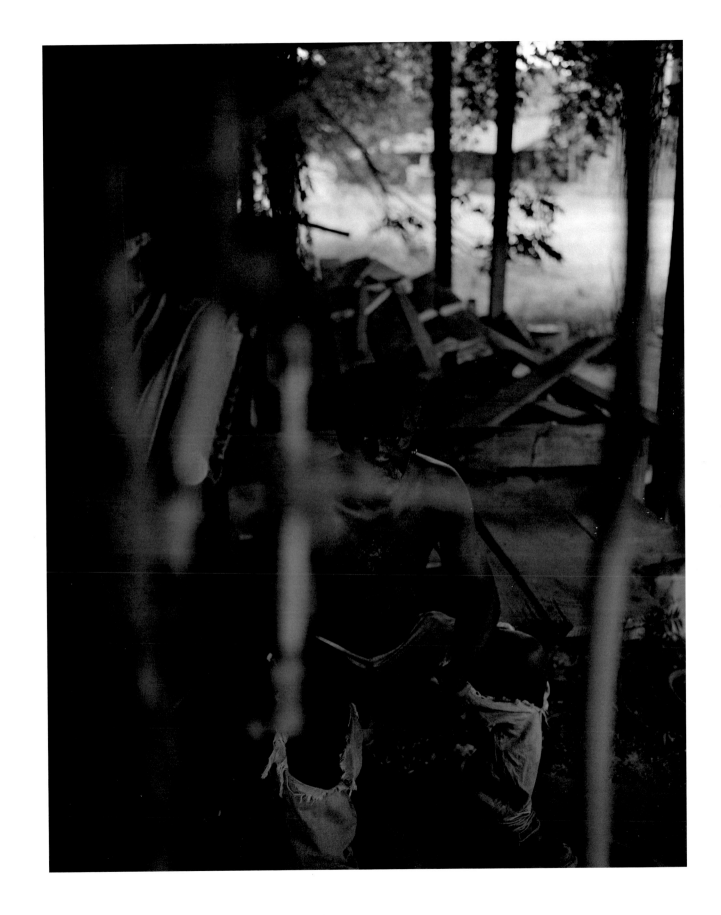

Levon inside the farm's old barn: "The first two years in prison were really bad. There are all kinds of criminals, it gets rough and you have to deal with it. I didn't want to be a different person but I had to be so I could survive and deal with the violence. Once you stand up for yourself, they leave you alone. I did good things in there, I saved two lives and I was respected. I never lost hope. I had not done it and I knew God was on my side. I just put it in his hands and I tried to do good where I was."

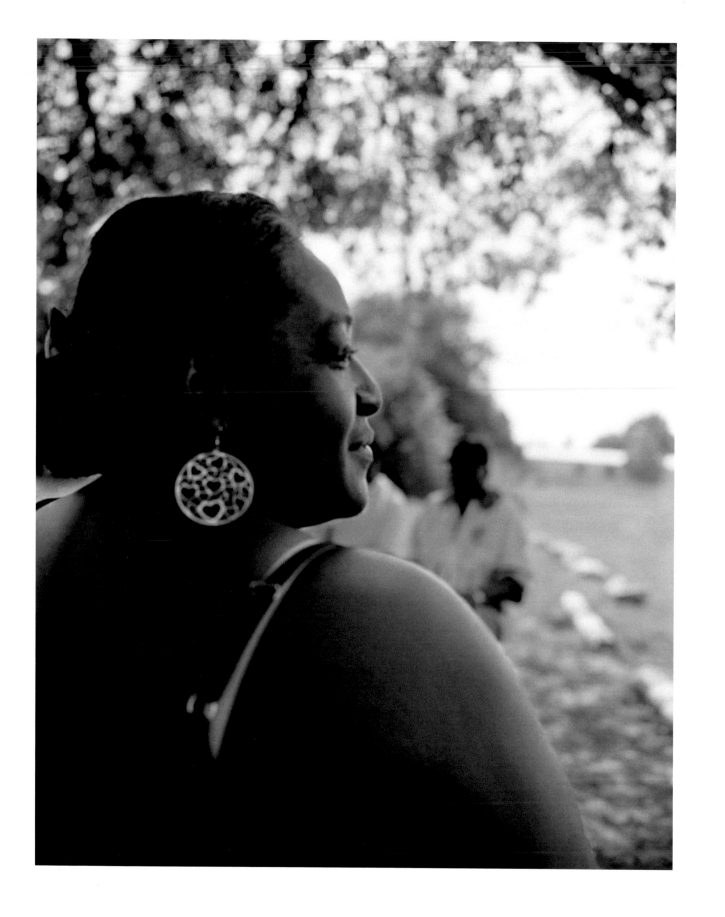

Dinah, Levon's wife: "I always loved the country and never wanted to leave. I worked all my life and owned all my trailers. I didn't depend on anyone and waited for the right man to settle down. I wanted to be better off than my mother, who was left alone with eight children to feed. I was also careful not to get in trouble down here because I don't trust it. For years, we had a prosecutor, same one who put Levon and Kenny away, who got rid of as many African Americans as he could. It was a racial problem with him."

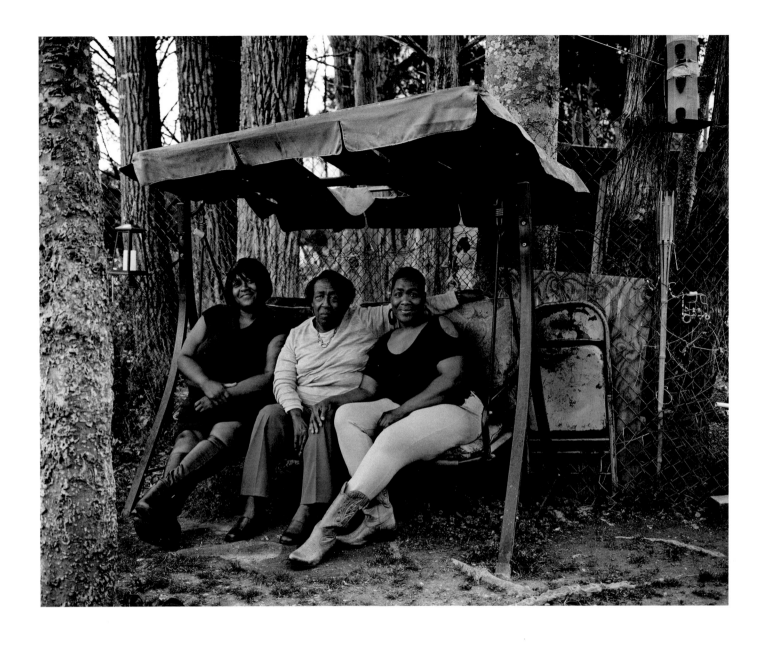

Dinah with her mother Virgie Fulton and sister Mary.

Virgie: "I was born on the plantation where my parents were born. My mother was a full blood Cherokee and I remember her folks working on the farm. As a little girl, I'd be along in the fields with my mom and help her pick cotton. But I didn't have a hard time because my father didn't allow us to work. He'd always say, 'Me and your mama are working and I don't want my children do something for nobody. Y'all do what I say you do, ain't no white somebody can tell you what to do.'"

Levon and his wife Dinah at Berdie's Restaurant.

Levon: "All this is behind me now and I still love everybody. When you hate, it hurts you more than you gain, but if you forgive, you can go on and have a peaceful life. I am living my dream life, I just got married, and all I'd like is to get a little bit of land and a house. I have been through so much, I just want to live life to the fullest and have some fun."

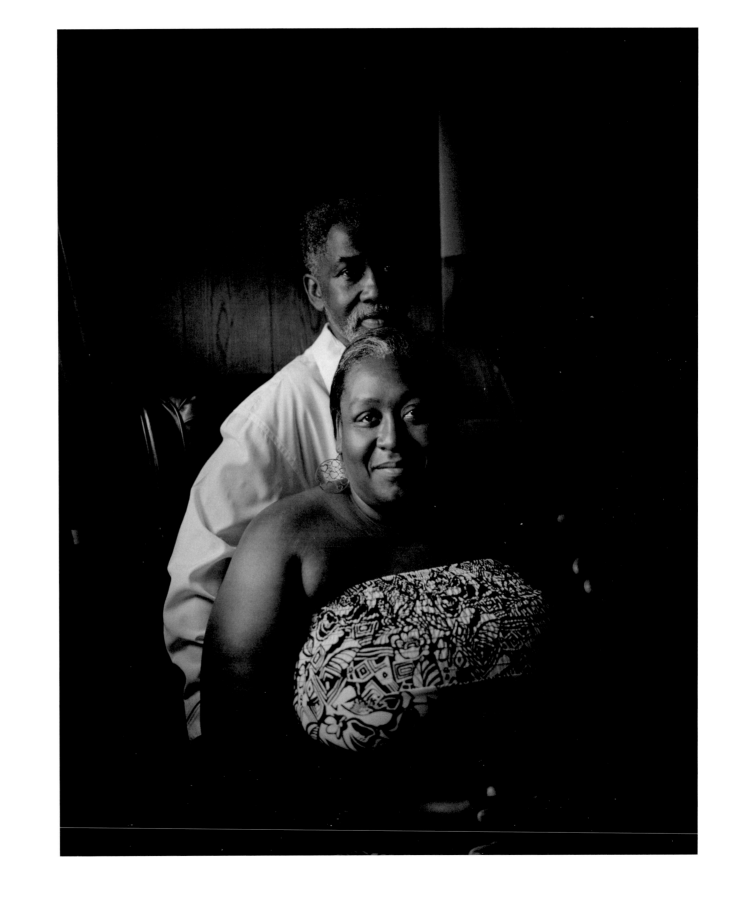

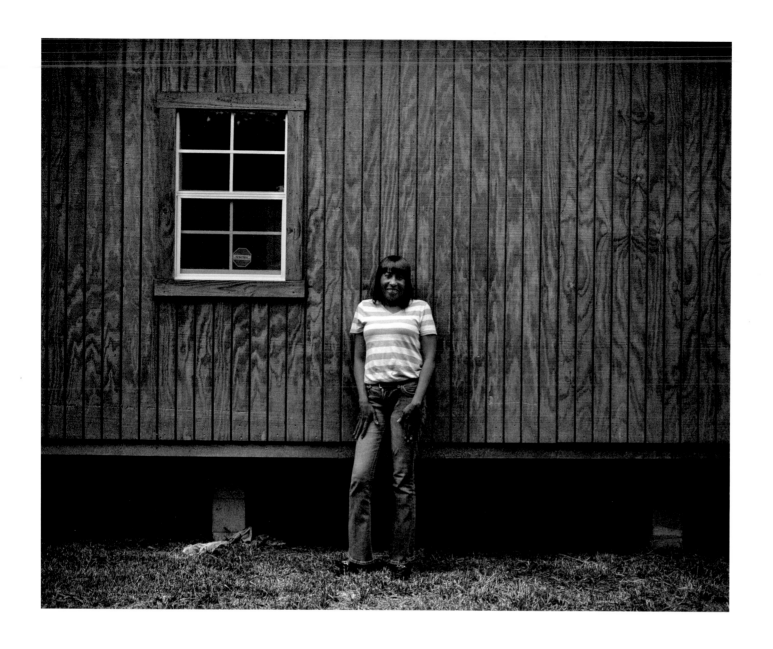

Martha, Levon's sister: "I like it here, even if we have problems sometimes. People judge you by the color of your skin. It's quiet but it's there. If something happens or somebody gets killed, immediately they think it's one of us. Some people treat you bad, I encounter it, but you have to ignore it. It's the only way to deal with it so it doesn't get to you."

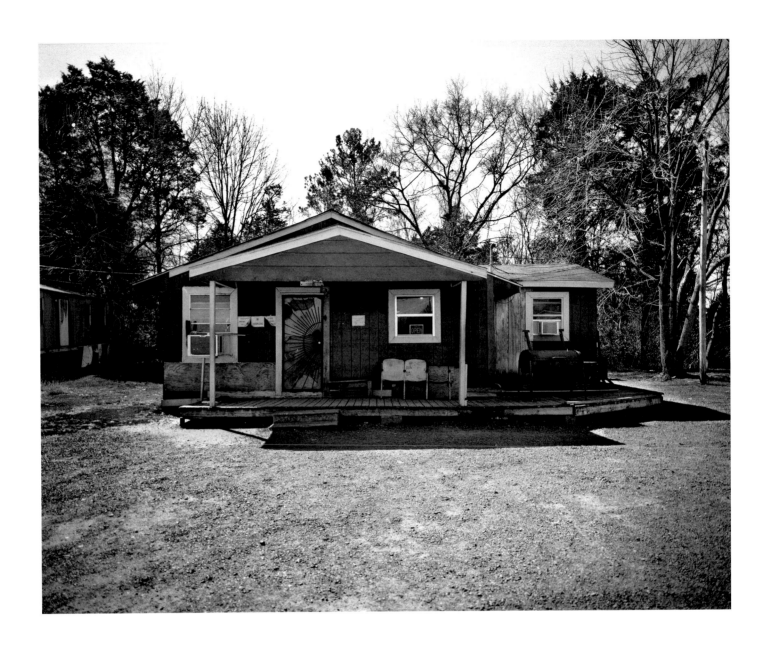

Berdie's Restaurant in Macon.

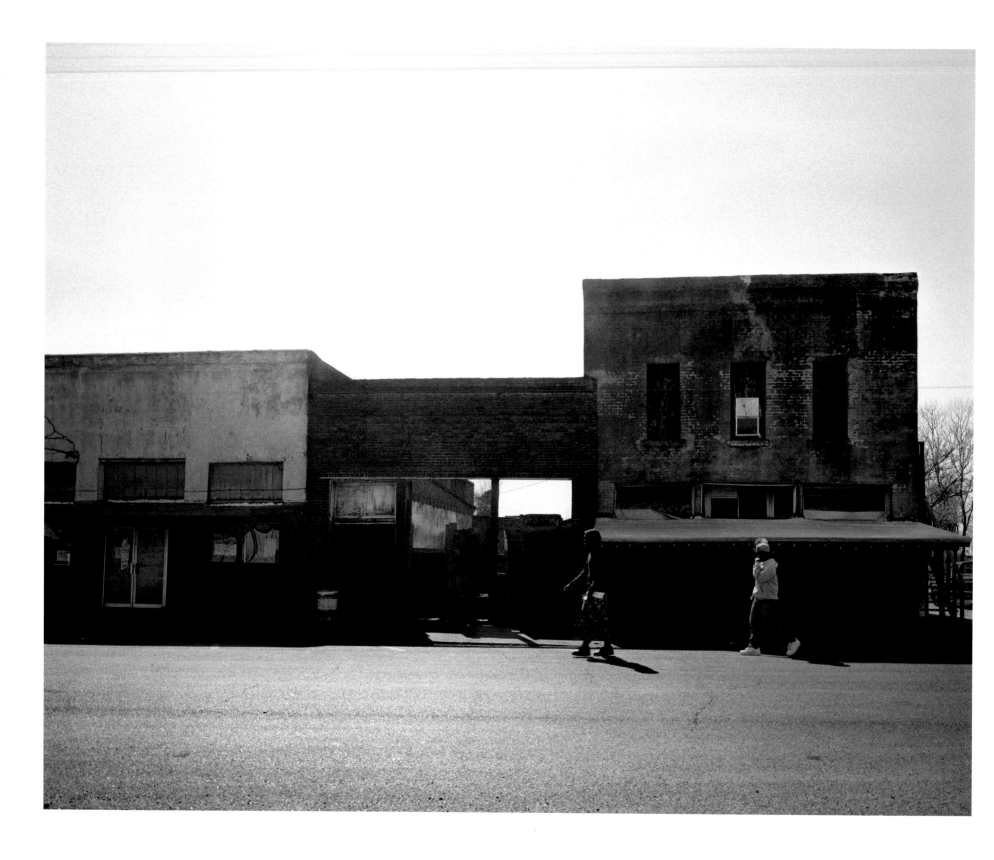

Main Street, Artesia, Mississippi, a village nearby. These two buildings house a social club and a nightclub.

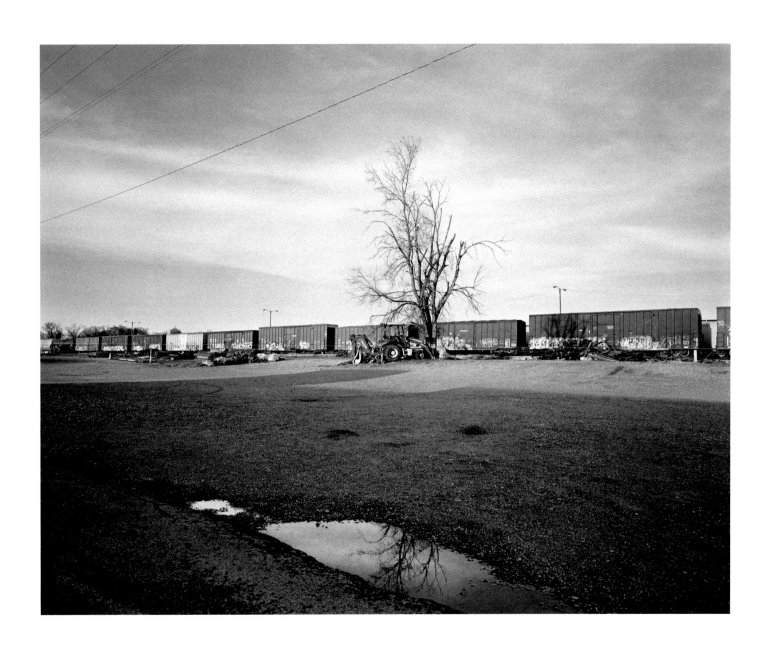

Abandoned trains across Main Street, Artesia.

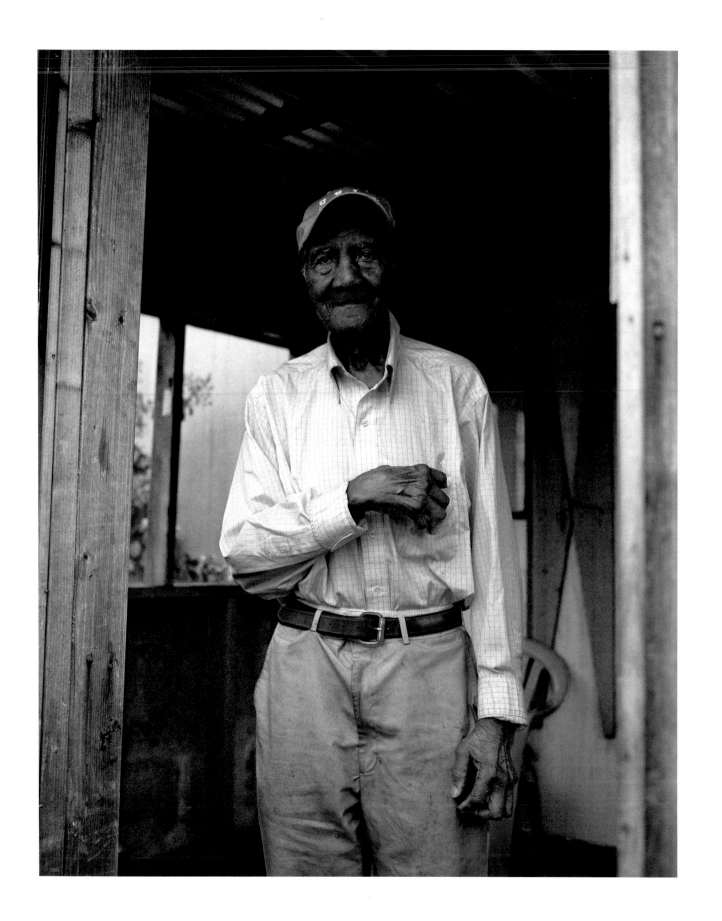

Horton Brooks, Levon's great-uncle, passed away in August 2016 at ninety-six. He was ninety-four at the time of this picture and stopped driving and mowing lawns only the year before.

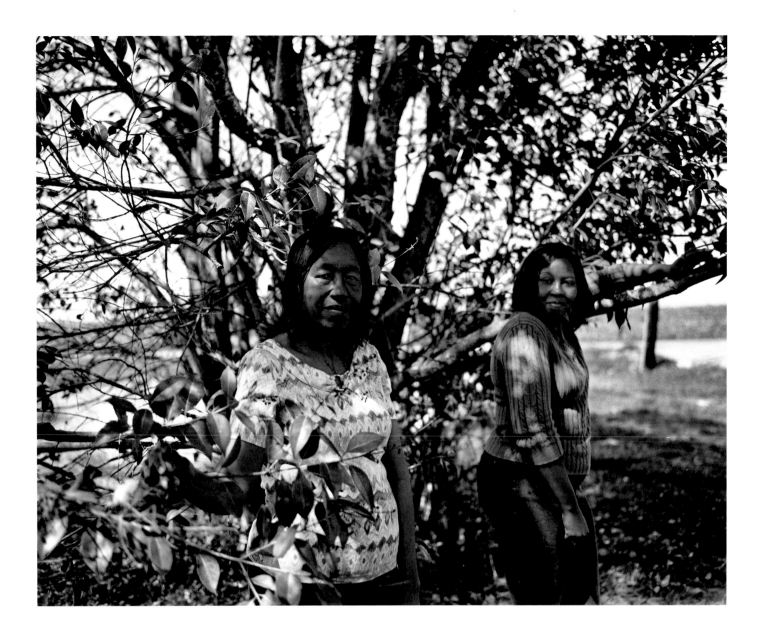

Patricia, Levon's sister, and niece Gloria.

Gloria: "I was eighteen when Levon went to prison, he was my favorite uncle. When the verdict came back guilty, we were in shock, it tore us apart. They didn't care who they picked and sent to prison. After that, he was hours away in Parchman. We wrote, we kept going out with my mom and my grandmother. The hardest part was leaving him down there. Life is good now, my biggest joy is my grandkids. I'm happy just like I am right now, going to church and living my little life."

Levon raises chickens, turkeys, quails, and rabbits for a living: "When I came out, it was hard. I had to leave my attitude in prison and adjust. I didn't recognize anything, everything had changed in a bad way. Our communities are destroyed by drugs, violence, and poverty. We have to go back to the way we came up and take care of each other. Kids are the most important and they should have a better life than we did. Some things are better. Back in the day whites ran everything and we didn't have a say, but with the Civil Rights Movement, we could move up. But this is the state of Mississippi so we are not quite equal yet."

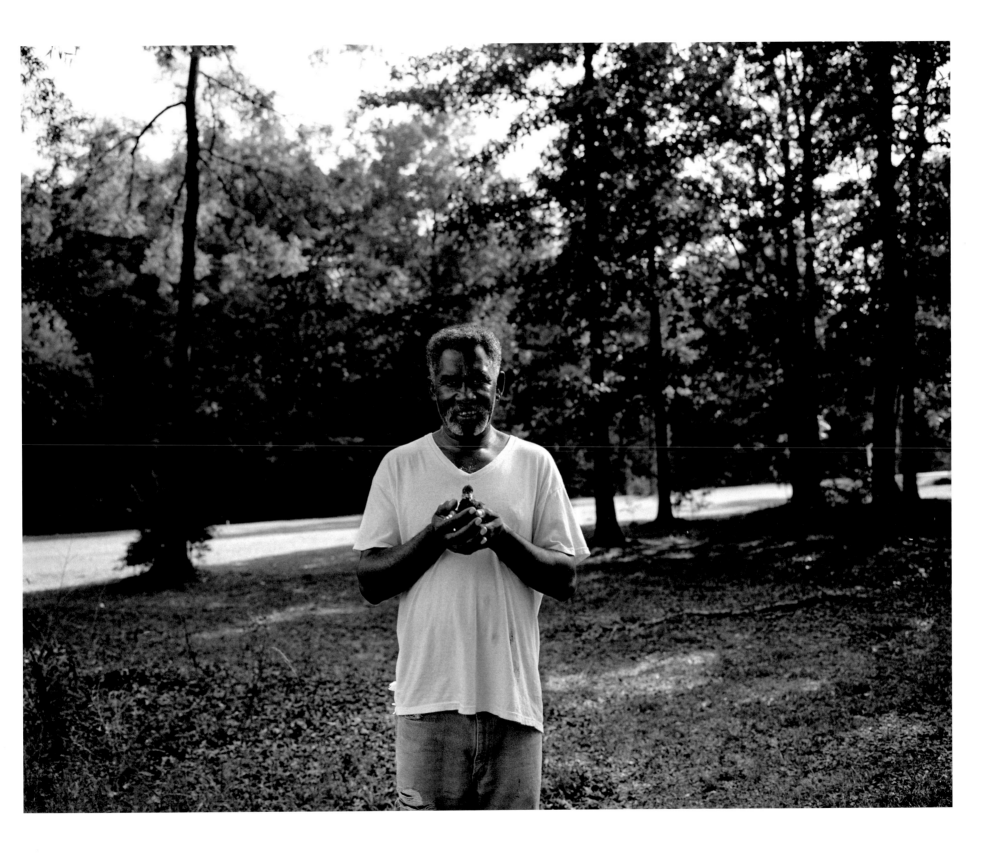

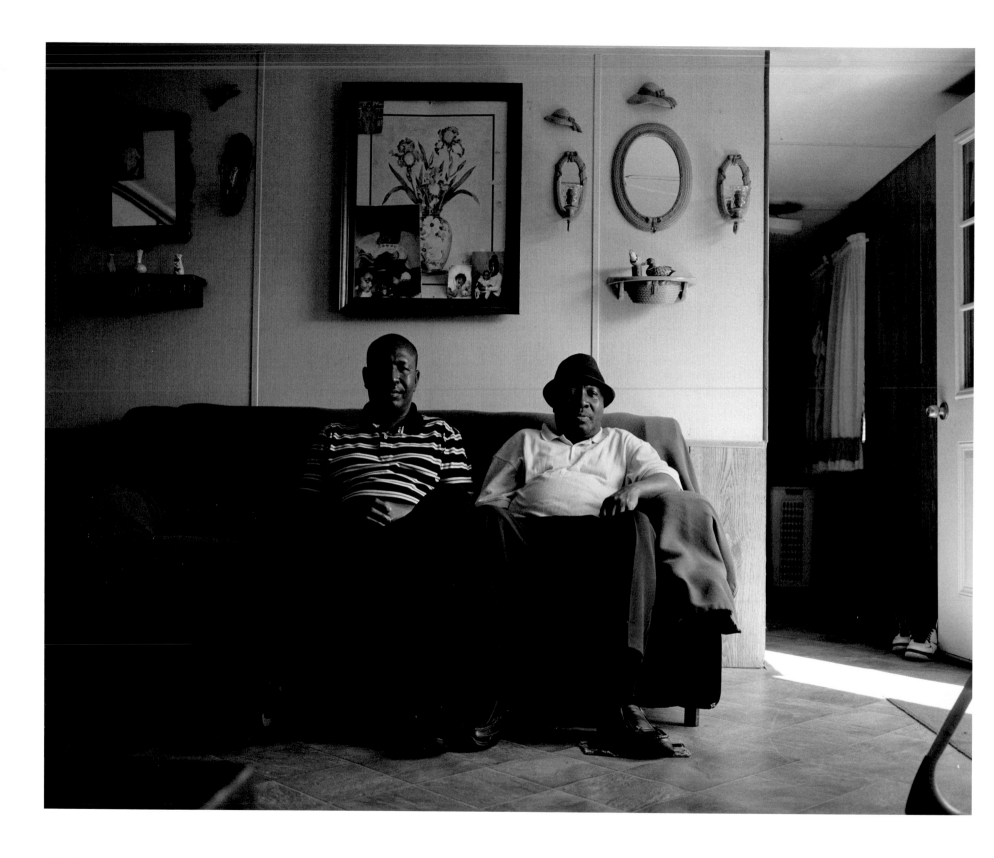

Edward-Earl and Jimmy, Levon's nephew and brother.

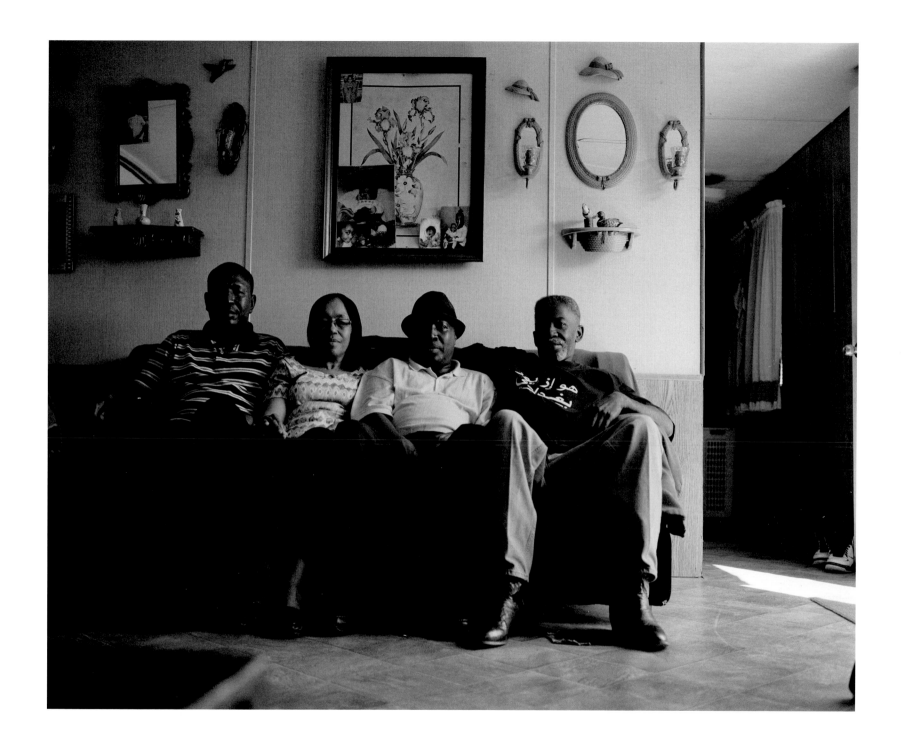

Edward-Earl, Patricia, Jimmy, and Levon.

Patricia: "I am rejoicing Levon is free, because we worried a lot. Now I try not to worry about anything because it takes you down. It was so hard on my mom and that's why she got so sick. But when we told her that he was getting out, she said, 'I knew he was getting out all the time!' That's the faith she had. I have eleven grandkids, and three great grandkids, I love them and they're always around me. I like it here, I have my own home and I'm happy with my life."

At the crossroad between Hardy Billups Road, Levon's street, and Gilmer Wilburn Road, going to Artesia.

Opposite: Doris Walker, Levon's favorite aunt, who passed away in September 2017: "My parents were sharecroppers and they rented land to farm. They raised corn, peas, okra, peanuts, and each year my father would take cotton to the gin to make eight or nine bales to sell. There was seven of us and I was a tomboy. I always wanted to go with my older brothers but they sure didn't want me along. When I was eight, I started to babysit all my younger brothers and sisters. I had to wash and cook and have everything ready for when my parents came back from the field."

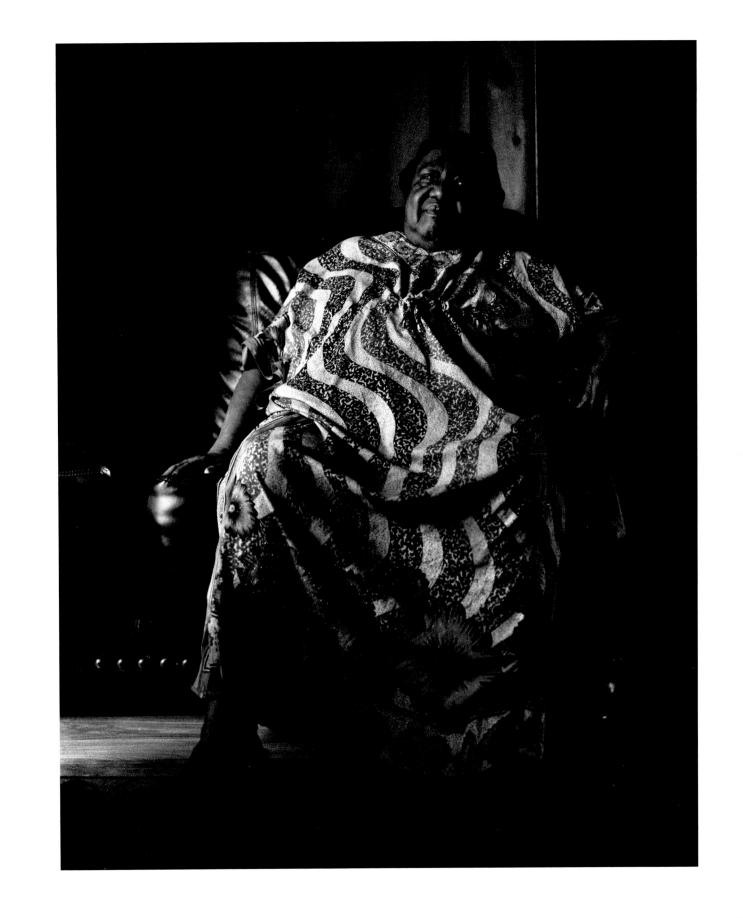

Precious, Levon's niece, with her children, Jordan and Aya.

Precious: "I had a great childhood here because I was very close to my sisters and brother. Now the environment is different and there's social media. I don't think it's good for kids; that's all they focus on instead of books and other things. My two children changed my life and everything I do is for them. They deserve a better life and that's why I want to go back to school. If you have goals in life, chase them, because you might not have another day."

Jordan, 10: "I play on the school team and I want to be a NFL player, but I'd like to stay here with my family."

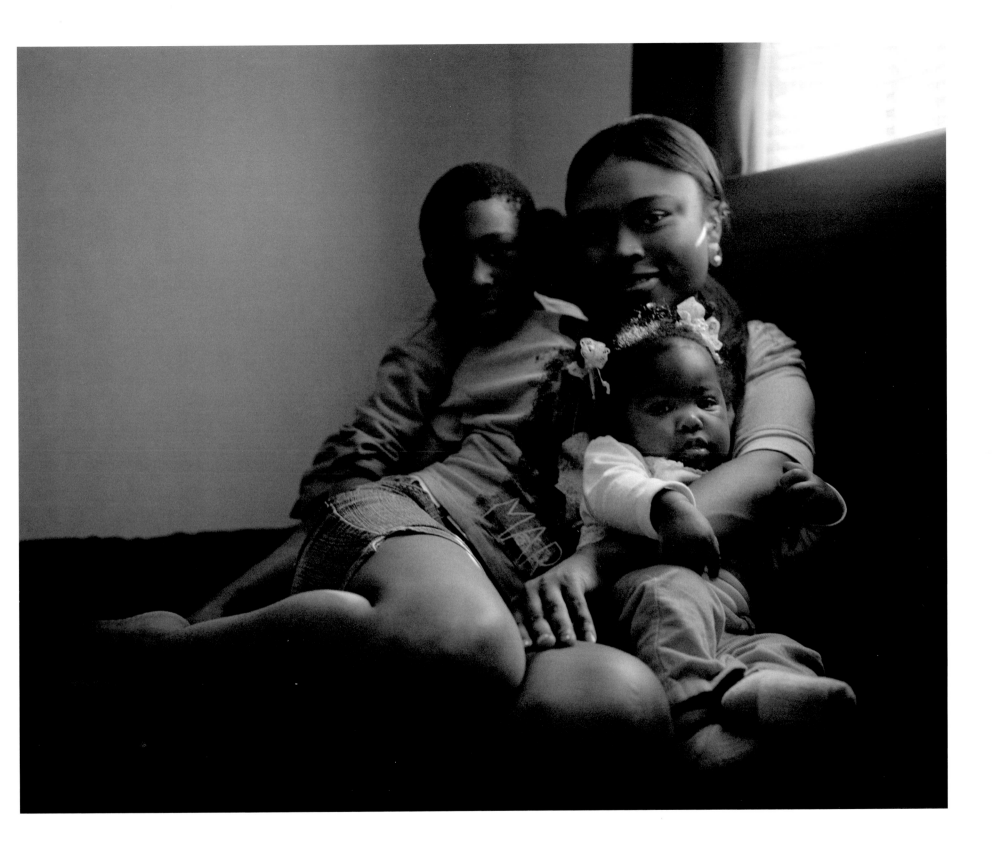

Kaziya, 12, Levon's great-niece and Laquandra's oldest daughter: "I want to be a teacher and a track athlete. I would like to go to college out of state in Alabama."

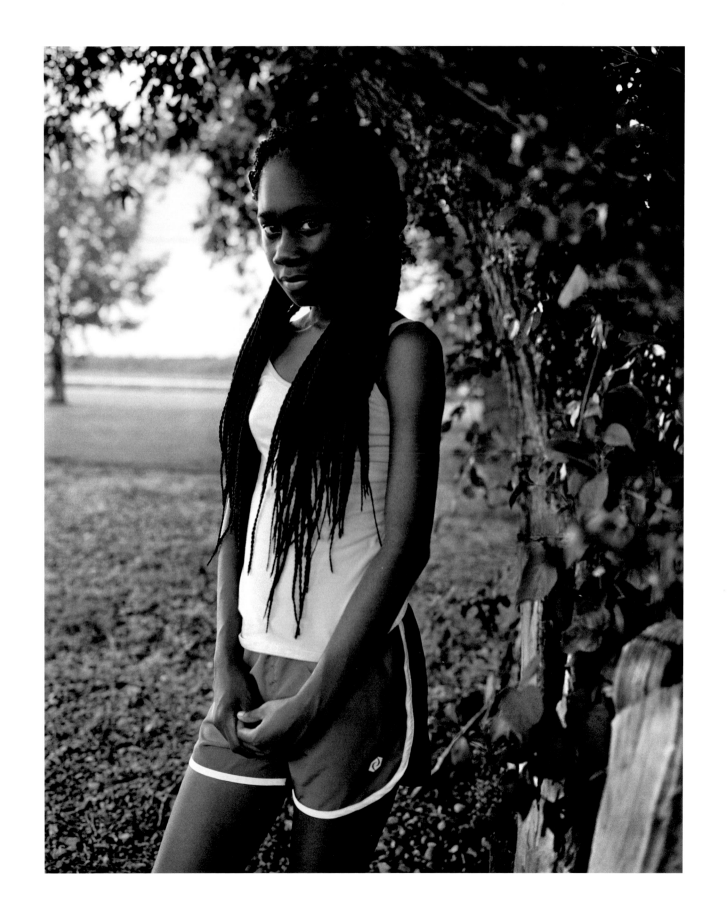

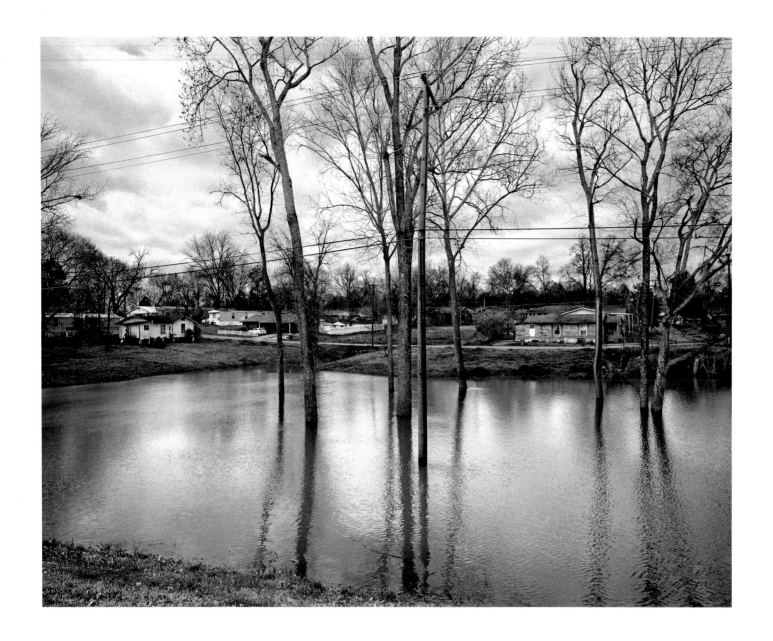

Downton Macon, home to Laquandra, Victoria, and other family members.

Victoria: "I love being close to my family but I'm thinking about moving to Texas. There's better jobs there. There's nothing to do here and there's prejudice. You realize it as you grow up. People don't want to know you. Some people won't even touch your hand in stores, they put the money on the counter. Maybe there's hope. I was in a college town the other day and two white boys sat with us to have a conversation, that was cool."

Victoria and Laquandra, Levon's nieces, with their children, Howard, Jasmine, Omyra, and Brylan.

Howard, 8: "I love baseball, video games, and movies."

Jasmine, 6: "I dream about my grandma, I love her. I would like to be a doctor."

Omyra, 7: "I love math and want to be a math teacher."

Brylan, 2: "I want to be a policeman."

Laquandra and her fiancé Jaquontae.

Laquandra: "I want the best for my kids but the schools are not great. If you are poor there's nothing for kids, no after school programs, no camps. Nothing to do, that's how kids get in trouble. I am thankful for my family, I have my life and I don't worry about it, but things aren't right here. Most white people are prejudiced. I had a couple of white girlfriends but their families didn't agree with it. We had to hang out in places like the car wash and hide, and they were too scared to come to my neighborhood."

Jaquontae: "I'd like to be a welder and have a good job to make things better. I'm just thankful for everybody in my life because there's nothing to do down here and there're some problems. It's not just race. Some people think that they are more than us because they have more, and they only deal with each other. People greet you, talk to you, but they don't hang out. I don't think it will ever happen here. Maybe in Columbus where some schools are mixed, so they grow up being friends and it might come along like this."

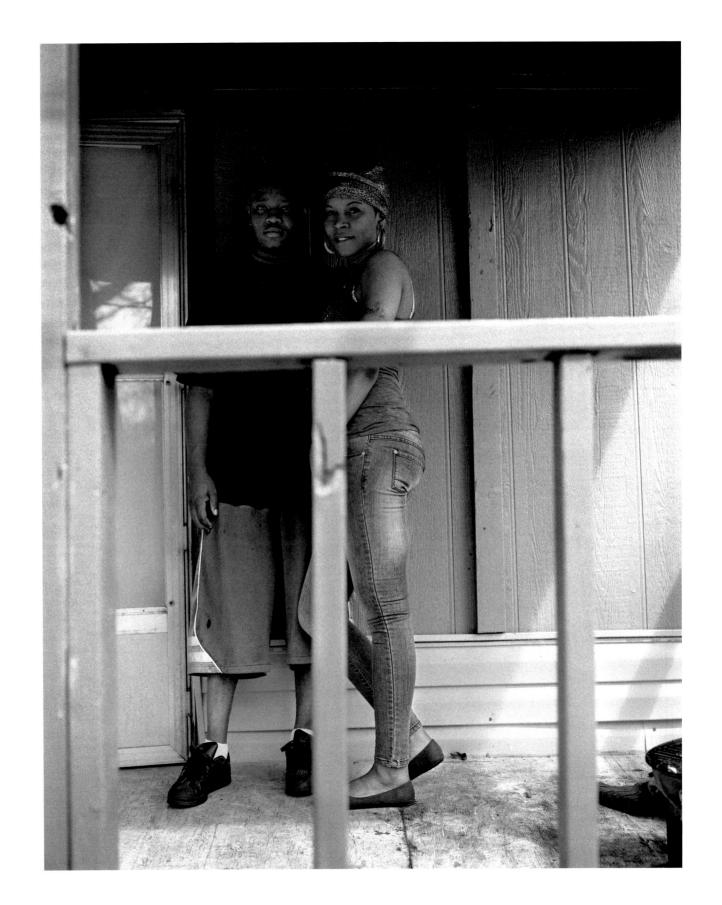

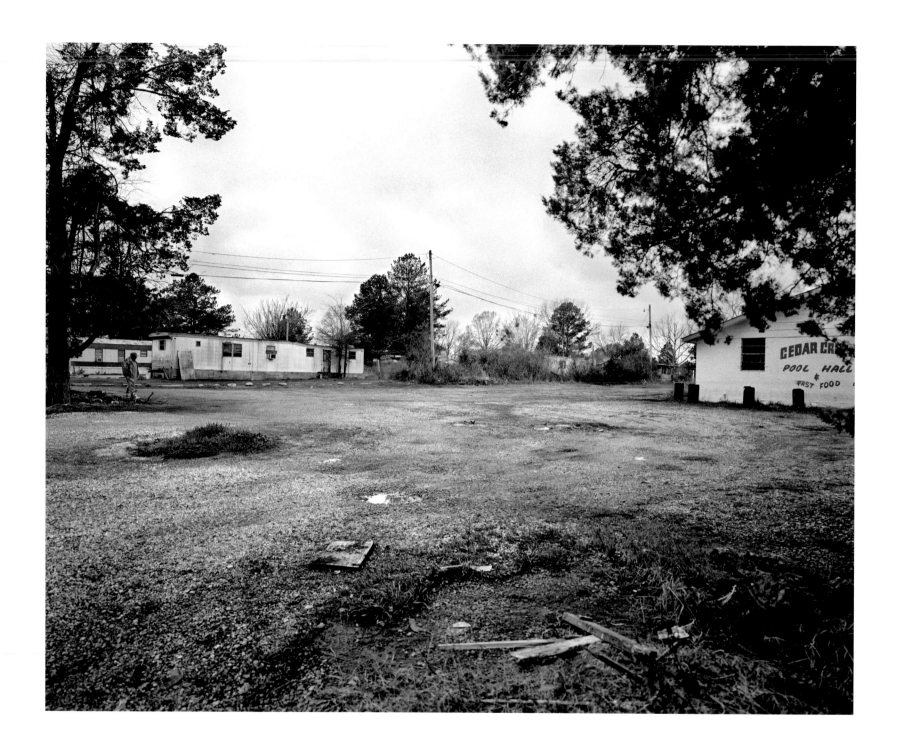

Richard Brooks outside his home. The pool hall next door closed after several shootings.

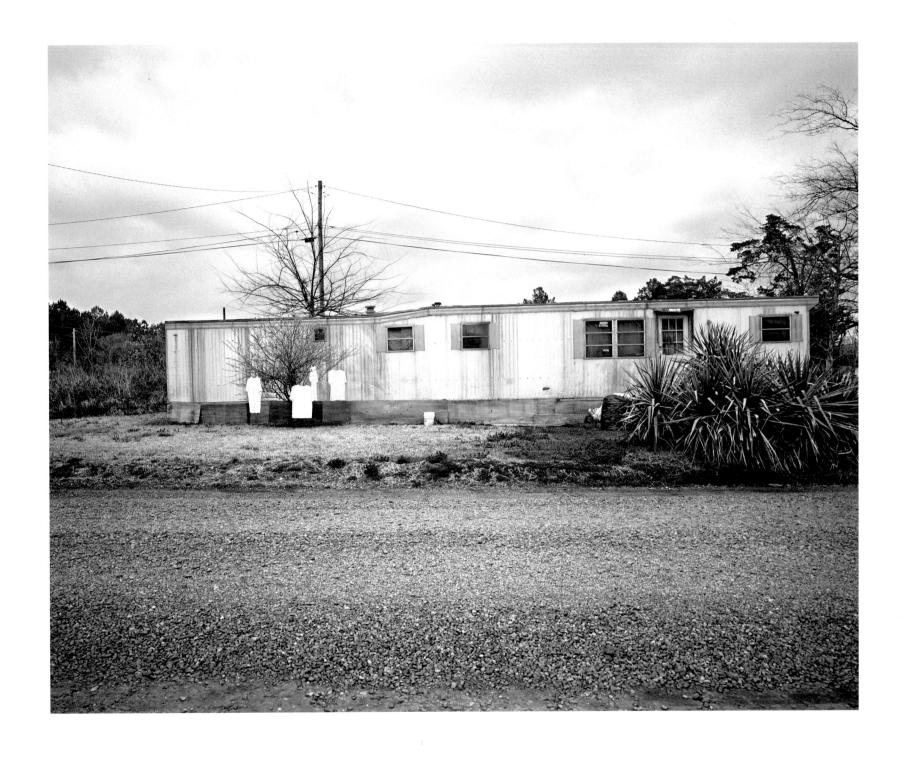

Richard's home in Macon.

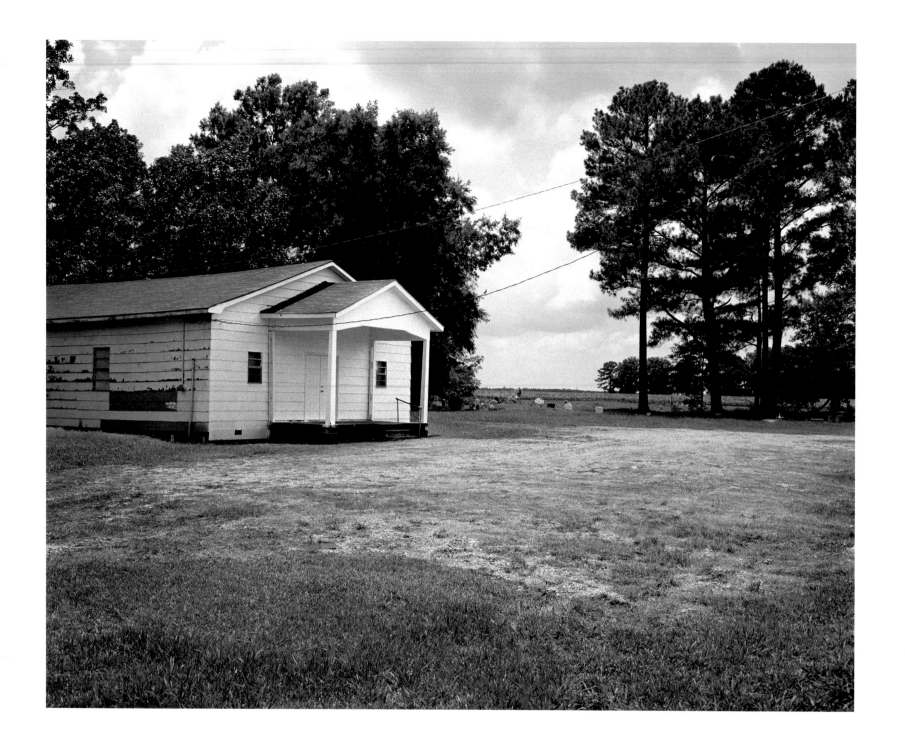

Levon's childhood church and its cemetery. His mother, Bertha Lee Brooks, is buried there.

Richard: "My parents were sharecroppers on a farm, us kids had to work hard for everything and there was no time for school. You'd work to the bone for three dollars a day up to the 60s. We had to like it the way it was because we couldn't go to many places, and to be mad didn't do you no good. Me and my brothers didn't get in the mix of the Civil Rights Movement, out here in the country you had to watch out for yourself or meet a bad end."

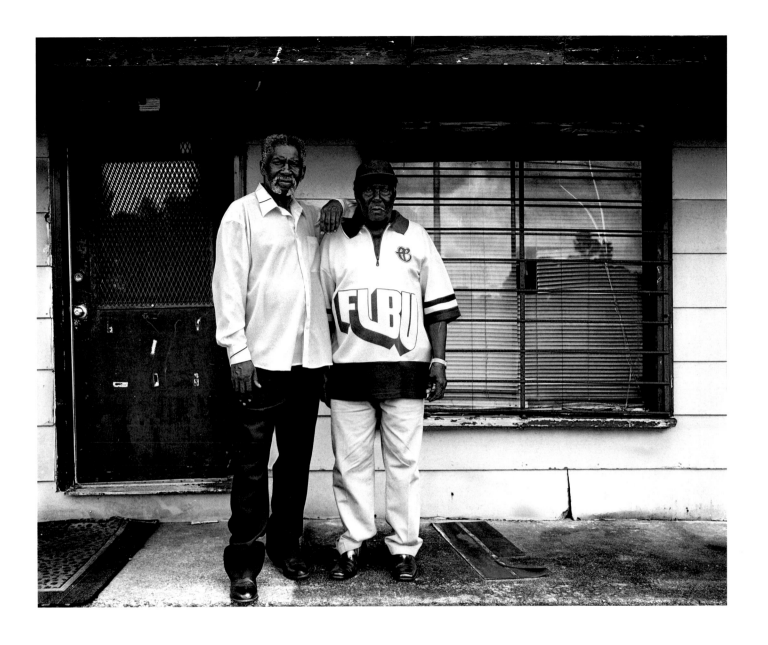

Levon and his father Richard, at Bertha's old house, where he lived after his release.

Richard: "When Levon went to prison, it was the worst time of my life and it lasted many years. I believe if he was white and had a little more money, none of that would have happened. They didn't care who they were going to get. I want to forget it. Right now, I'd like a better life, more money, some peace and quiet. I worked on the plantation when he was growing up, we could do better but then we'd have to leave what we had here."

Dinah and Levon's Cafe under construction behind their house, where they celebrated their wedding.

Dinah: "I just married the man I love and our life is great, but I would like to have a couple acres
and a little house where we can have some peace. Right here, we deal with violence, drug infesta-
tion, mental illness, and incest from abuse or ignorance. Back in the day, parents would know who
you were courting, and they'd tell you, he's kin, you can't go out together. Now families are broken.
It depends on the family, but many young people are just trying to survive and don't have much to
do here. They go around being cute and get in trouble."

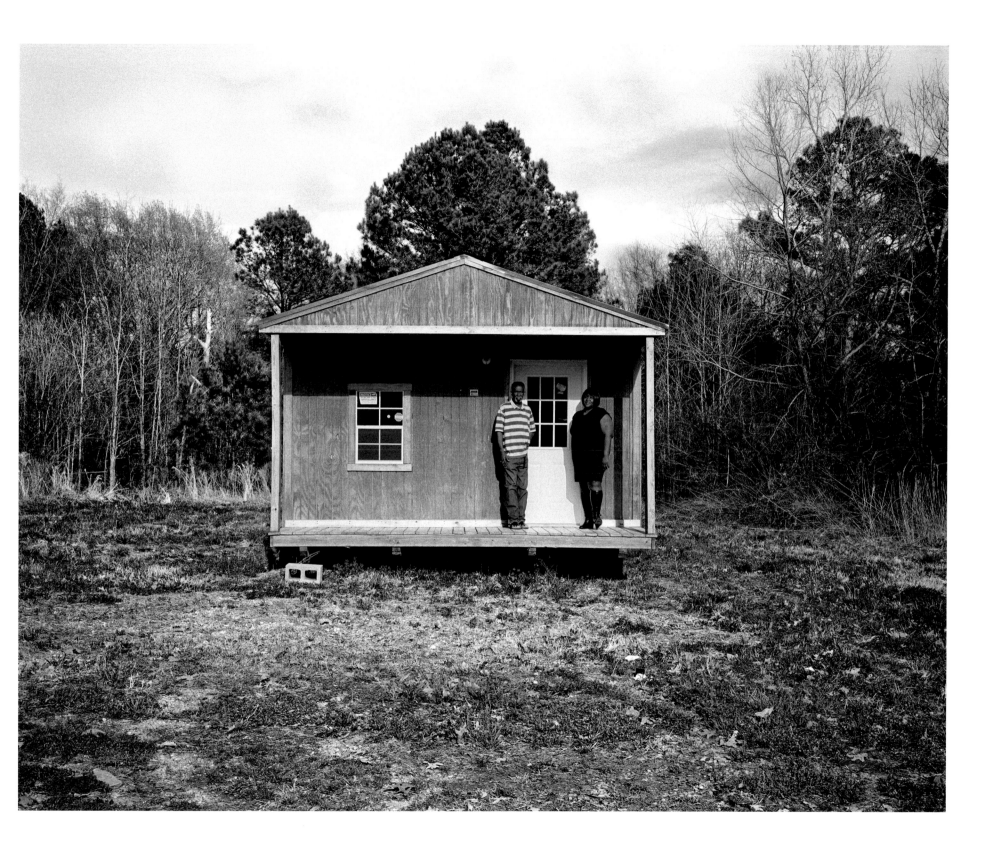

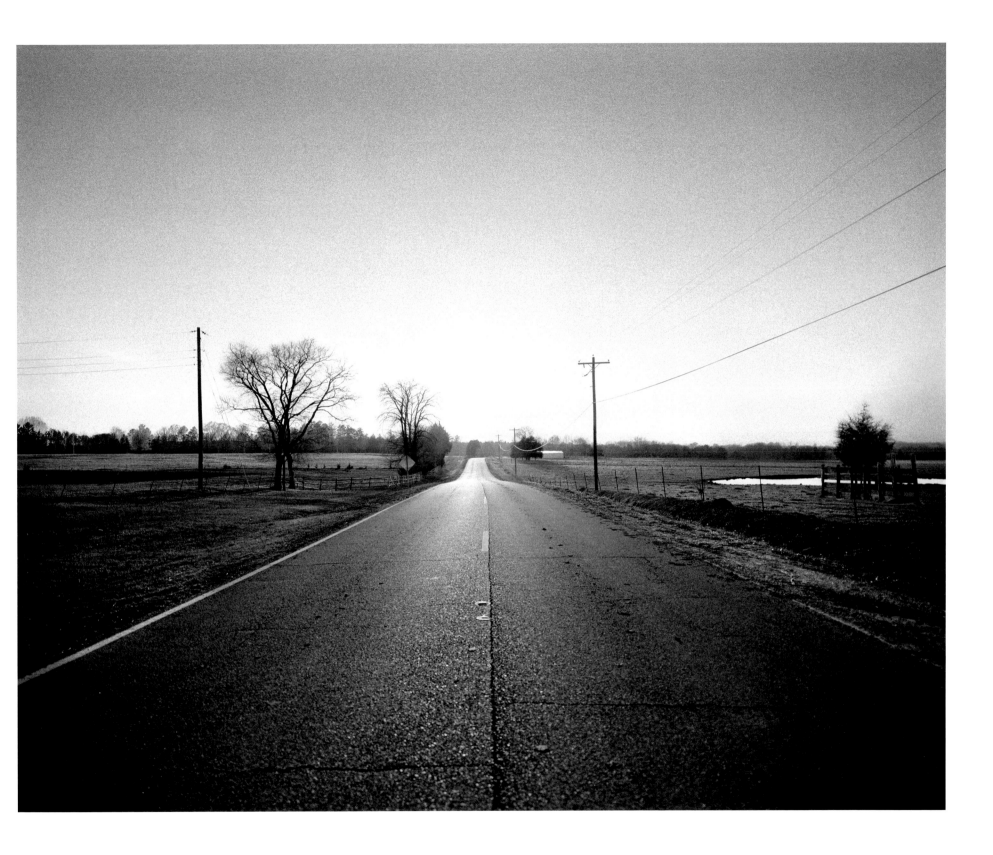

Lindsey Ferry Road, going to Levon's house.

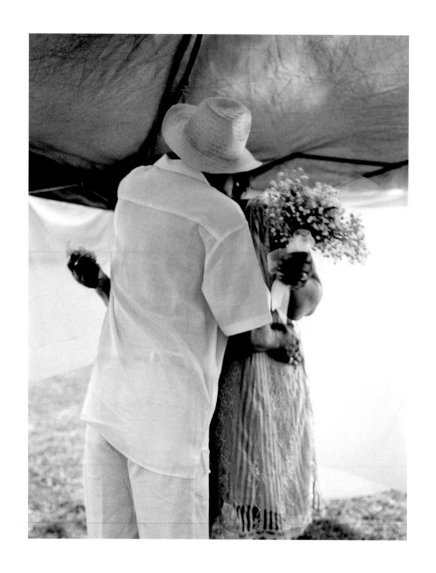

Mr. and Mrs. Levon Brooks, June 5, 2016.

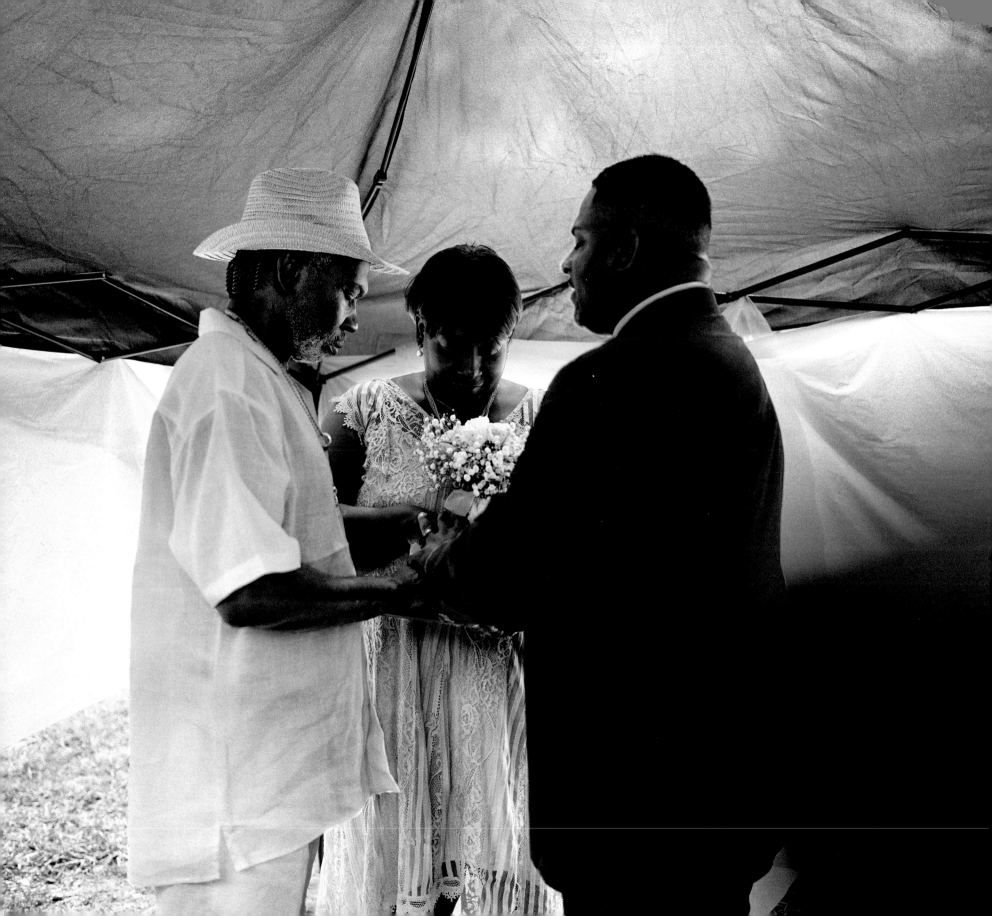

KENNEDY BREWER

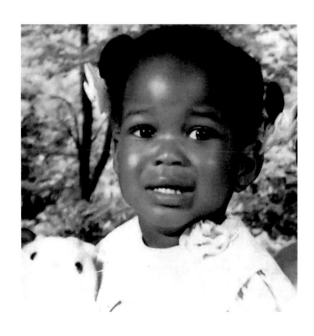

Christina Jackson (1988–1992). Her body was found in this creek in Brooksville's countryside.

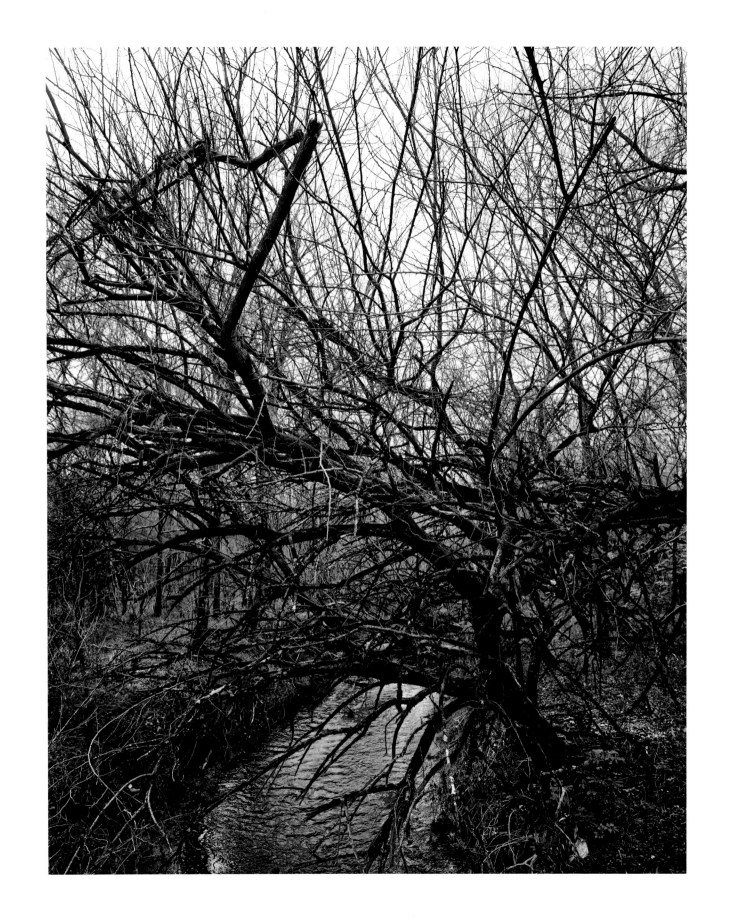

Kennedy on Pilgrim's Rest Road by the family church: "Death row can destroy you. You're in there alone twenty-three hours a day and you go out for an hour. You have a TV and that's it. But you can't think about the same thing every day, it will kill you. You need to get your mind off it and take it a day at a time, that's all. It was hard to do, but I read and I'd write letters, pass the time."

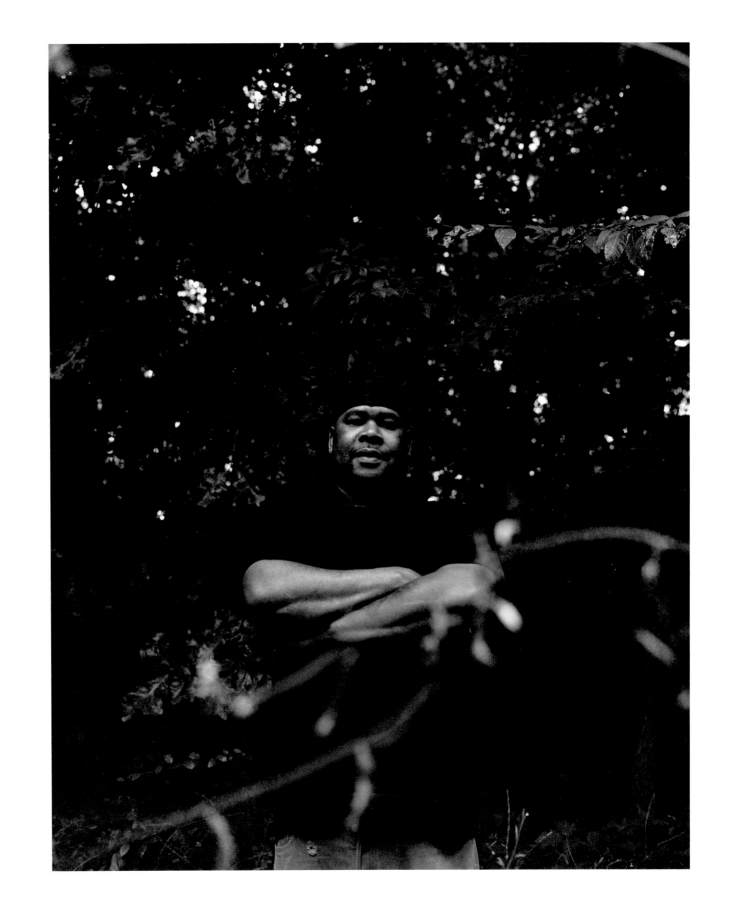

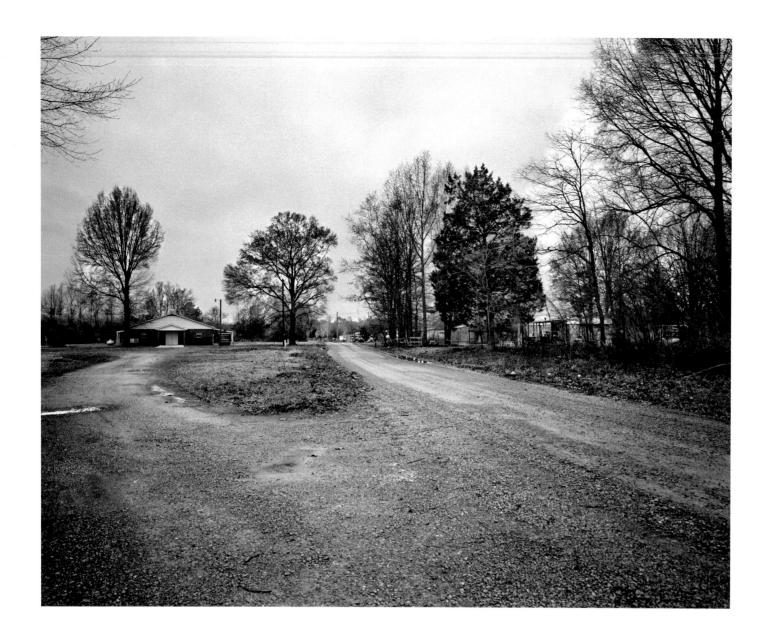

The family church in Brooksville's countryside. Many Brewers live on this road.

Annie: "I thank the Lord, after all we have been through. It was a lie. I stood up to Allgood (the prosecutor) and I told him that Kenny didn't do it. I raised him, and no son of mine would do this. I never lost hope, I knew he'd be free one day. I prayed and Kenny prayed. I don't know what he prayed to, but our prayers got him out. I don't care who you are and what you got, you got to put the Lord first. But I had to ask the Lord to forgive me because I wanted to whack Allgood!"

Annie Brewer, Kennedy's mother, on her 79th Birthday, July 3, 2013: "Back in the day, we lived on the big farm. The owners were nice and we had a garden to grow vegetables. I stayed on after my mother died when I was fifteen and I was picking cotton. I met my husband Charlie around then, I liked his friend better! But he kept coming around and we got married. We raised our fifteen children together until he passed. I worked making flowers, we worked all together blacks and whites, and people were nice to each other, but after work people go their own way. It's just a way of life down here."

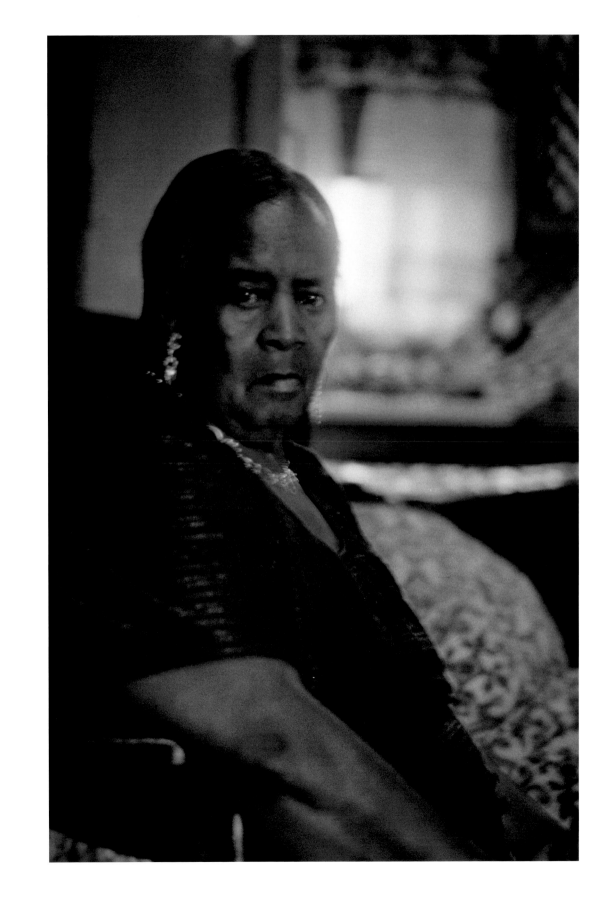

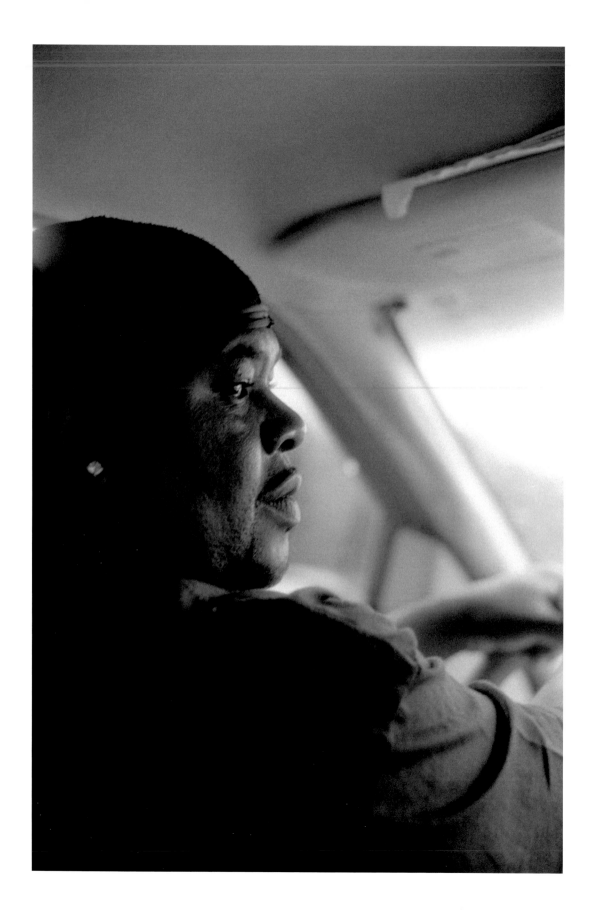

Kennedy: "I left prison and I never thought about it any more. I never looked back. I still had to pay a thousand dollars before I could get out, after everything I went through! But after that it was easy for me to just go back to my life here. I did good, some guys go crazy in prison."

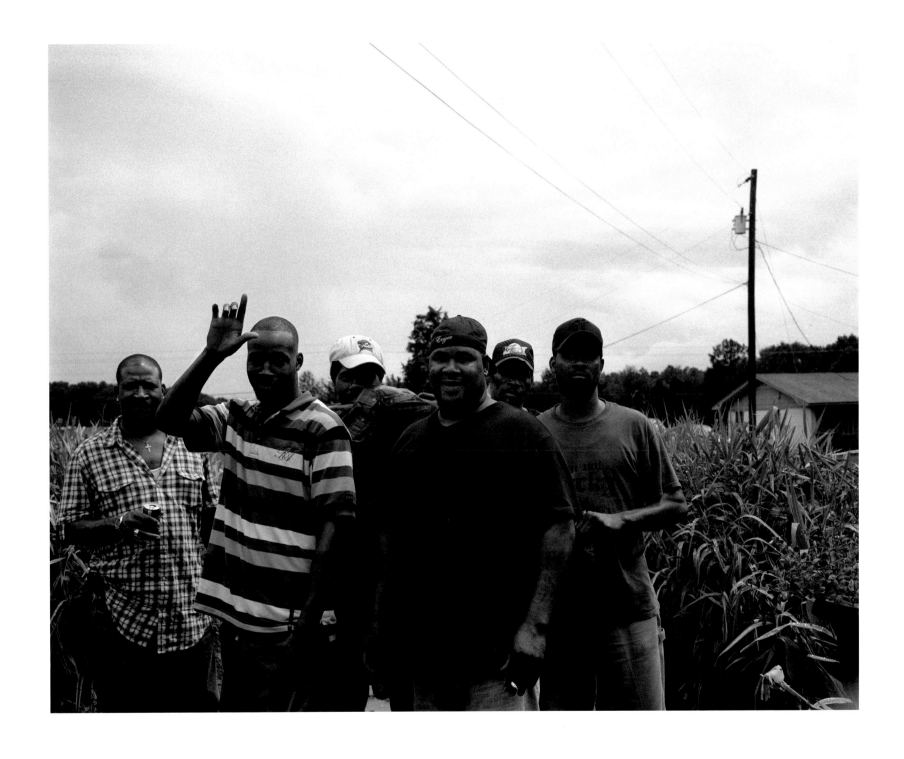

Left to right: Kennedy's brother, James E., nephew Tedric, cousin Robert, Kennedy, and brothers Clabon and Daniel.

Kennedy: "I never lost hope and I prayed. I knew I didn't do it."

Kennedy and his fiancée Omelia at their favorite Sunday spot at the Noxubee River Refuge.

Kennedy: "Life is good now. I go to work and I am just enjoying life. I always loved the country, the peace and quiet. I had a happy childhood running around free and growing up in a tight family with all my brothers and sisters. I didn't know that we had less than some people."

Omelia: "I always wanted to be a teacher and I became one. But when I taught fifth and sixth grade in public schools, I didn't like it. I loved working with the children and the feeling of teaching, but not the system. I currently work as an assembly line worker building engines for 18-wheelers. I absolutely love my job, but I dream of owning and operating my own childcare center."

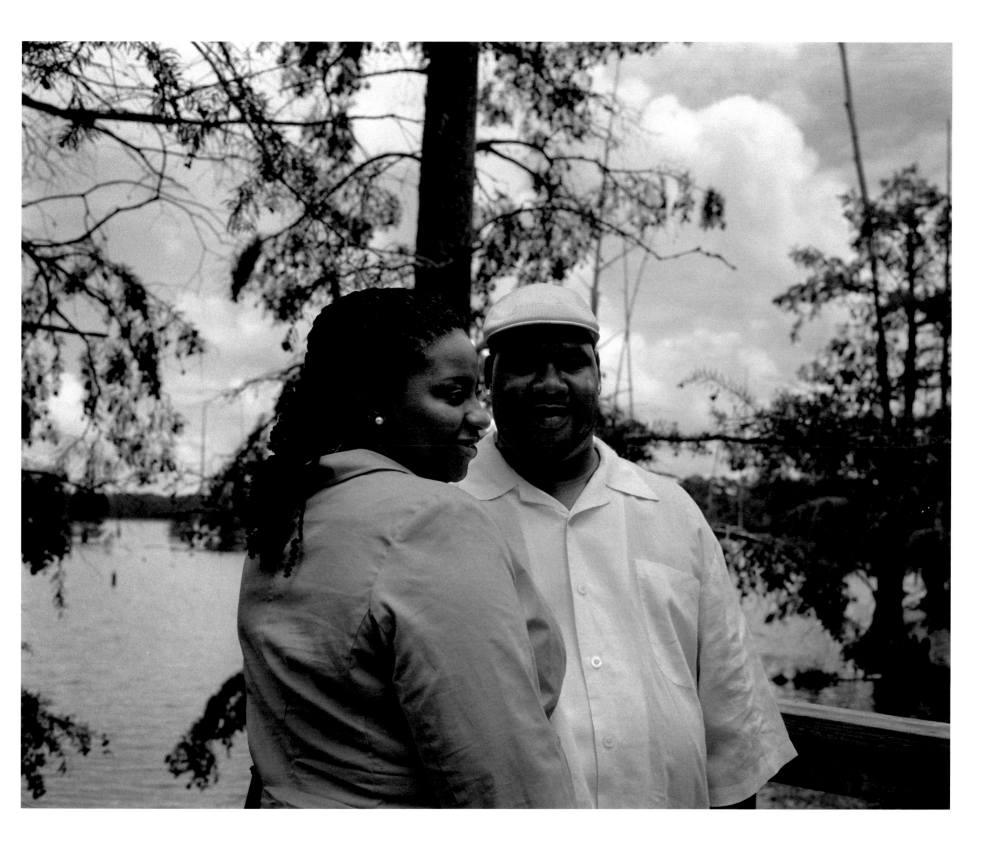

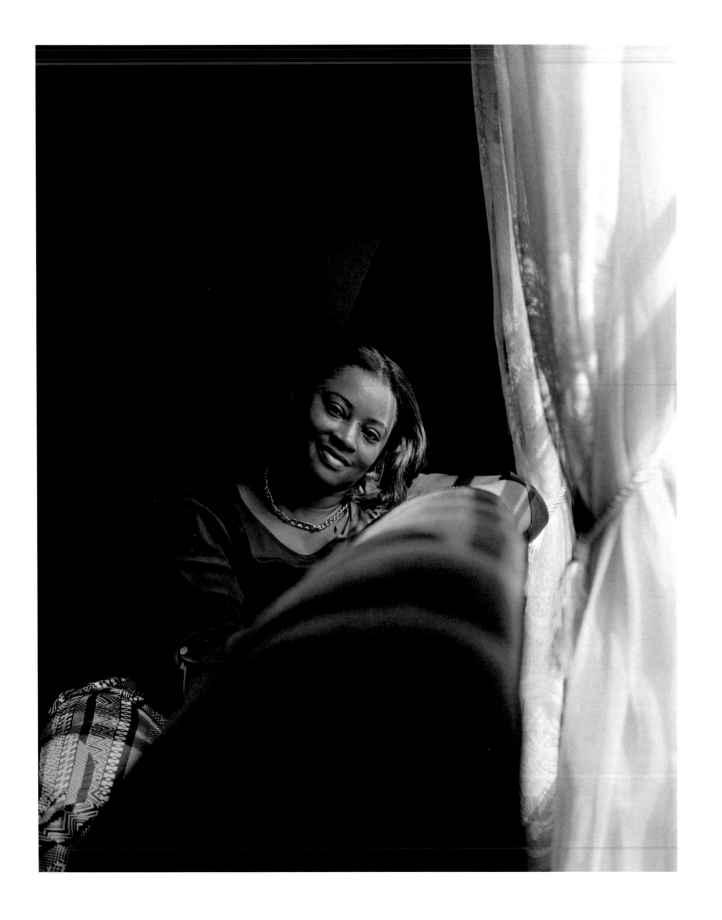

Marlena, Kennedy's niece: "I work at a center specialized in helping kids with behavioral problems and I love my job. We need a better environment and constructive things to do for poor kids. My commitment to my work is stronger because of Kenny. I heard shocking stories from other exonerees and it was a humbling experience. It can happen to anyone and I just thank God for life and the opportunity to enjoy it. The best part of life is the people I love, the places I've seen and the memories I made along the way."

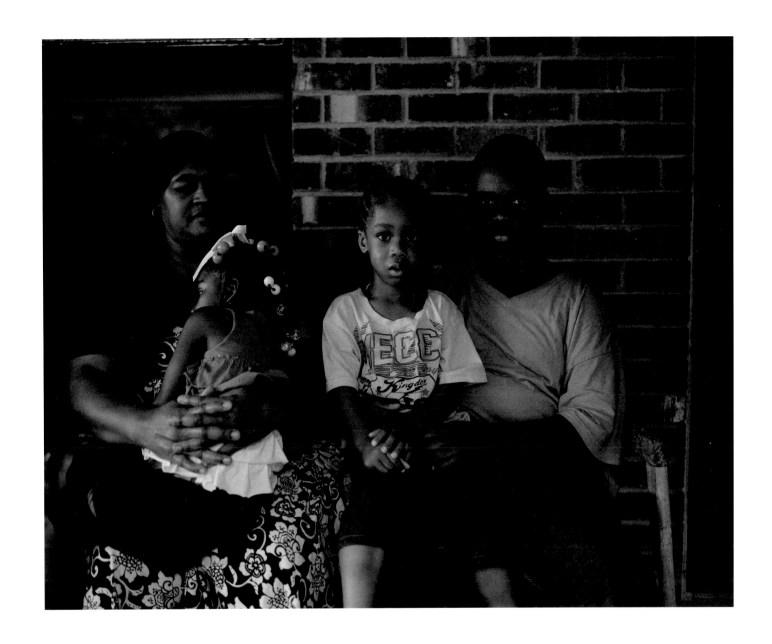

Martha, Kennedy's sister, with her granddaughter Royshylia, nephews Chrishawn, Kennedy's grandson, and Quindarious.

Royshylia, 5: "I like to be with my favorite cousins Azarion and Bryson. I love my bedroom and I read books to my little sister on my bed."

Chrishawn, 5: "I like basketball and I want to be a truck driver but I am not sure."

Quindarious, 12: "I love to ride my bike, and singing in church. I lead the choir sometimes. I want to be a football player, but it'd be hard to move and leave my family."

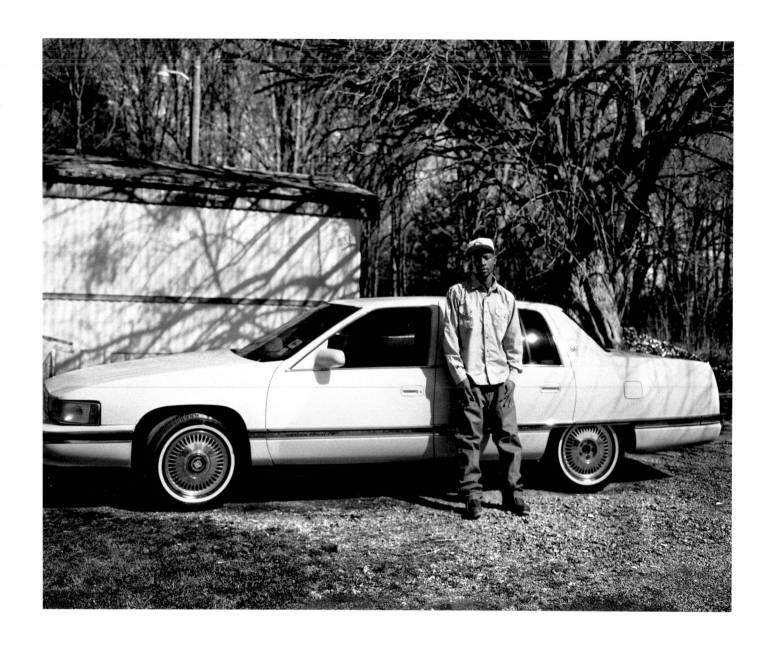

Tedric with his Cadillac: "I want to move away from here, I don't like it. I want to see more, live new adventures with my daughters, and meet people from different cultures. Here you can't even talk to a white girl, there'll be someone in her ear. The race problem is quiet but out in the open. You see that your boss only listens to your white co-workers. You'll hear him say that a black man should date only his kind. It will never change here, and I wouldn't try changing things because it'd be dangerous."

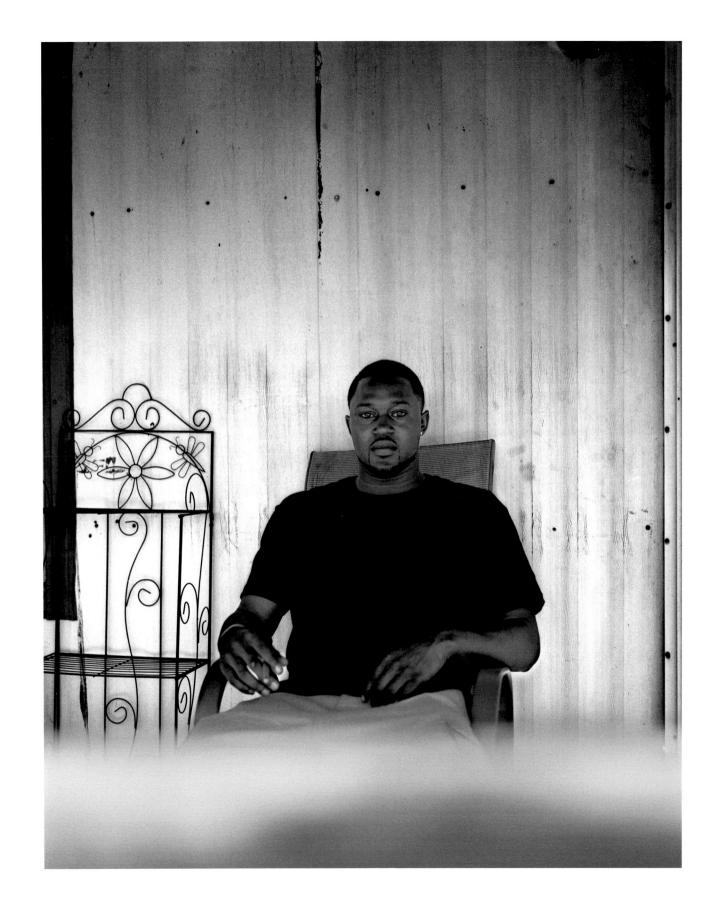

Mario, Kennedy's nephew: "I would like to move to Texas, there are more jobs there. I am a welder and I could make more there. There's not enough here for young people, for jobs and everything else. It feels like a retirement place. I traveled a bit and I want to see more things, have other experiences, and meet people from different races. We don't really have that many here and people don't mix."

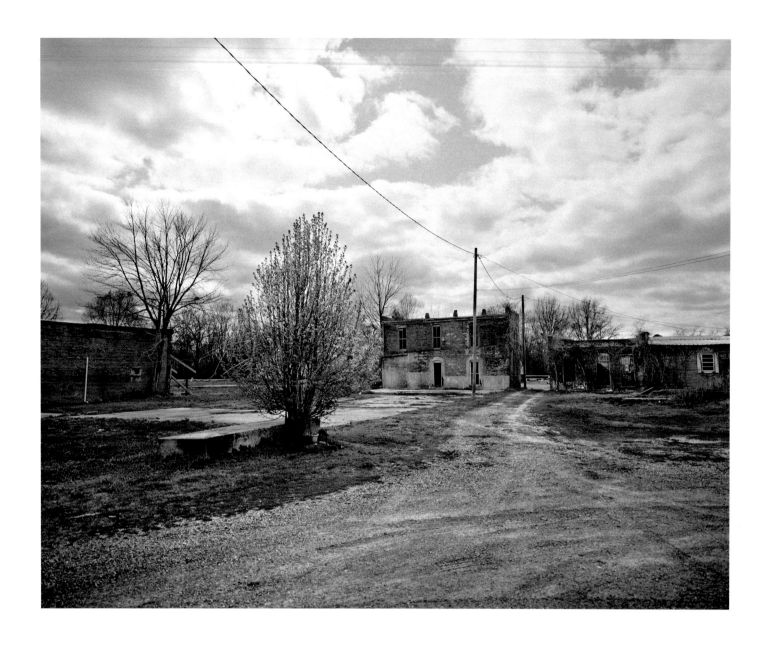

Downtown Brooksville, where Kennedy went to school. It was a lively town then.

Omelia: "Kenny has a sweet and humble spirit that drew me. He's a solid guy and we share some of the same traits. We are both loyal, hardworking, and optimistic people with the determination to be who God plans for us to be. We love to travel and explore new things. We are close to our family. We believe without family, life would be uninspiring."

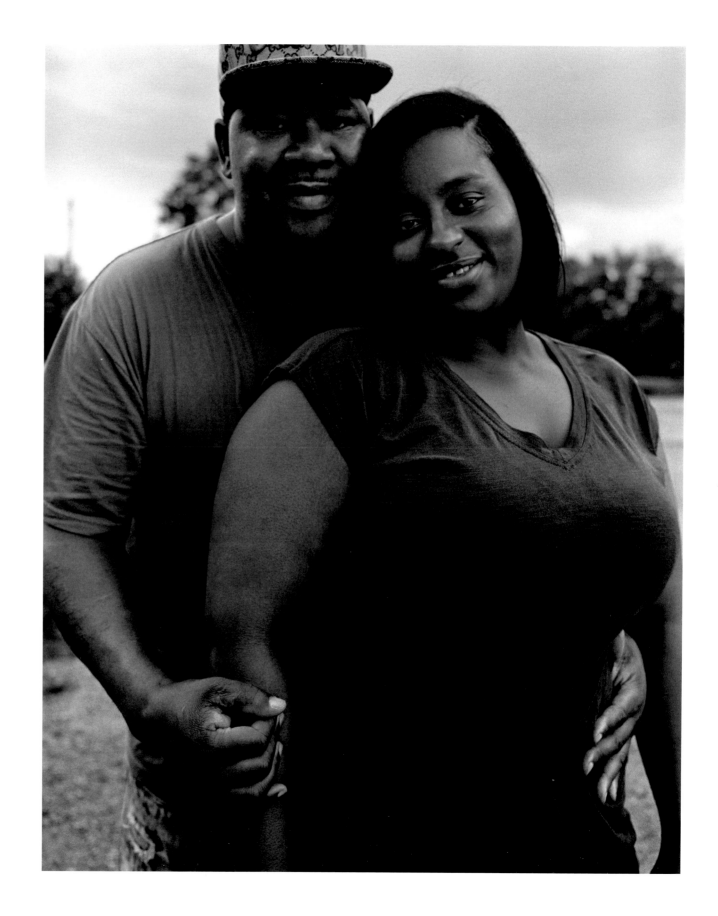

Kennedy and Omelia.

Kennedy: "That day I saw Omelia, I knew she was gonna be my woman. It's been six years and everything has been alright for me since we've been together. She is a sweet person and quiet like me. We like the same things and we enjoy each other."

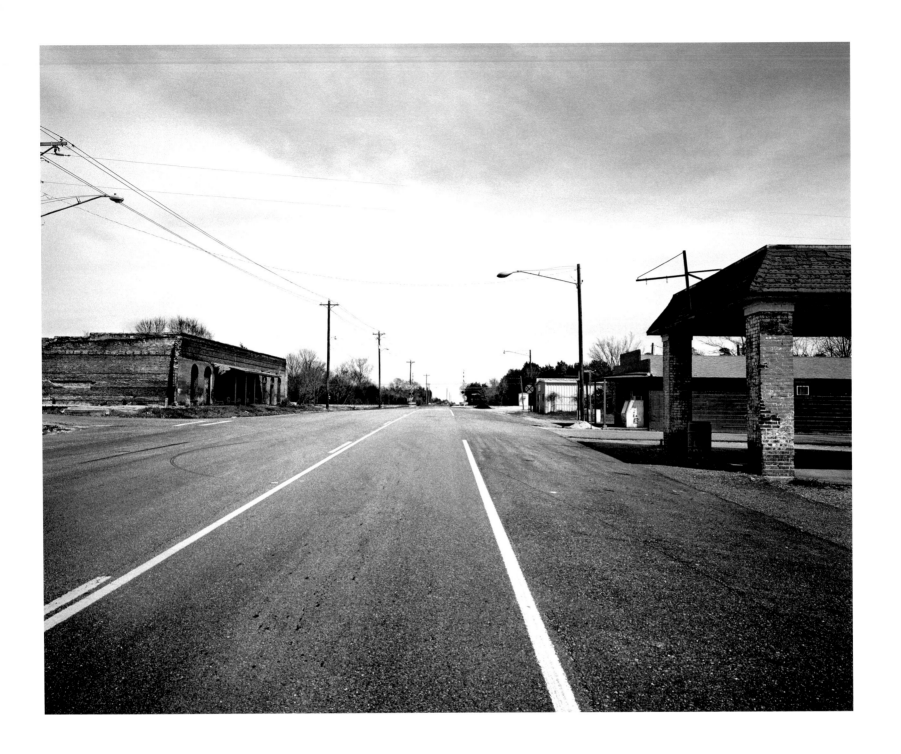

Crawford, Mississippi, a neighboring village with a deli, restaurant, and a nightclub on the block.

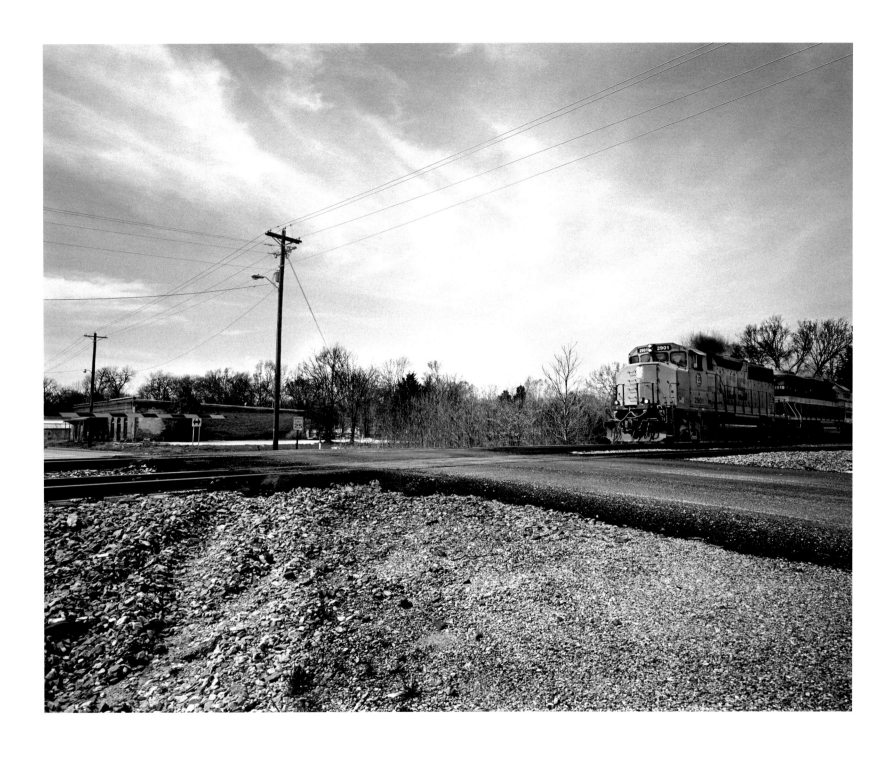

Crawford on the other side of the tracks.

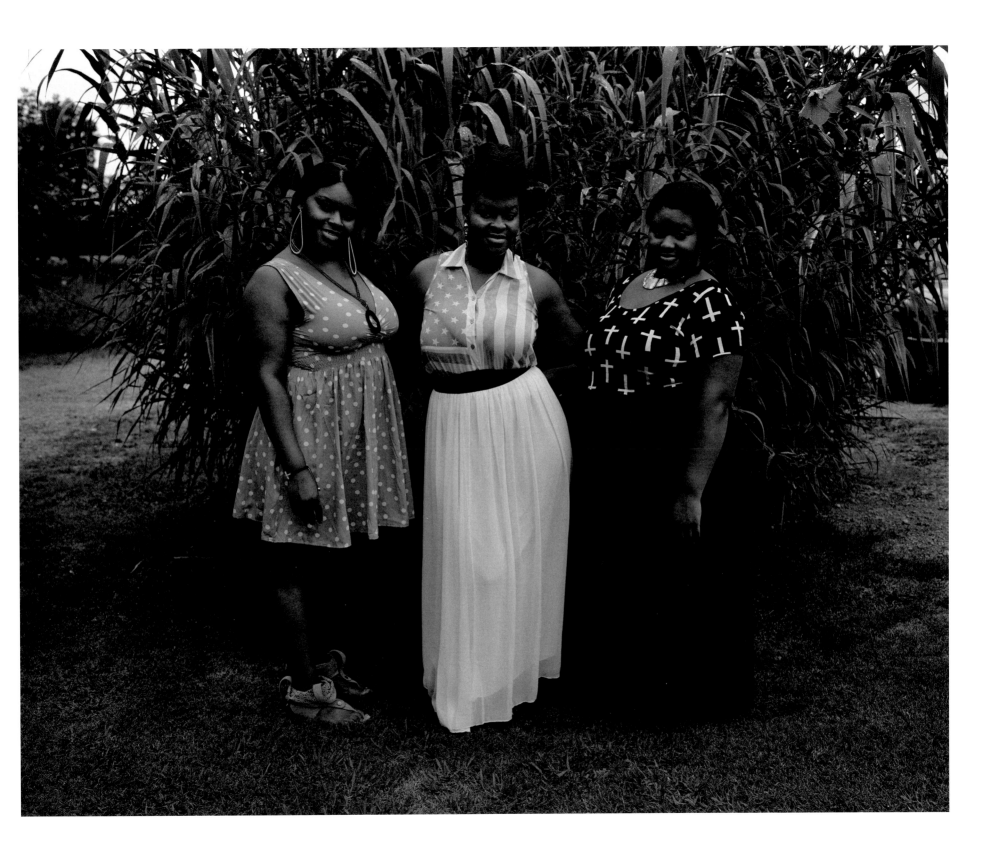

Sisters Taresa, Kayla, and Brittney, Kennedy's nieces.

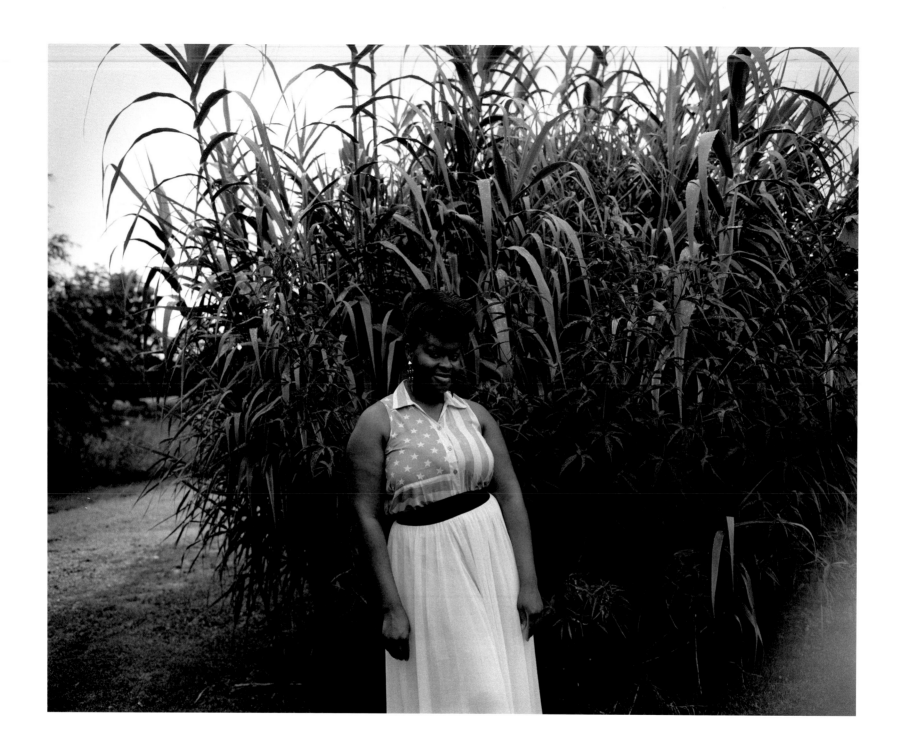

Kayla: "I love the country and being close to my family, but there's nothing to do here and there's too much violence. I don't like my job at the fishery but I am proud that it bought me a brand new trailer and provides for my son Blake. I'd like to have my own fashion boutique or study cosmetology and move to Atlanta or Houston. Somewhere bigger with more opportunities. And if I don't, I hope Blake will move one day and have a better life."

74

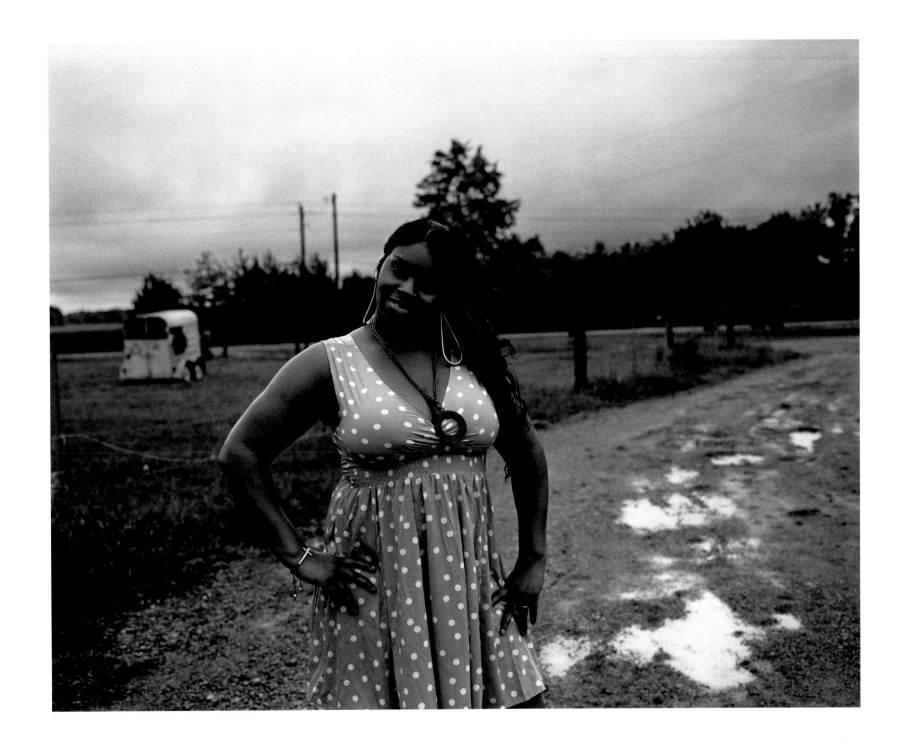

Taresa: "When my son R'nez was diagnosed with dwarfism, it scared me and I cried and cried, because people are so cruel. I don't think like that anymore, God gave me a unique person and I can handle this. Everybody just loves him and knows him around town. He is so special and smart that it made me feel some kind of peace. I'd like to go back to school to work in special education because we have so many special needs kids in the family."

Downtown Macon.

Paulena: "I just bought a little land and would love to build a brick house but for now I'll just move our trailer there. I also dream for my son Quindarious to be a football player. I hope he'll have a chance because our schools are not so good down here. Last year, he was punished for talking in class, and they broke his finger with a paddle!"

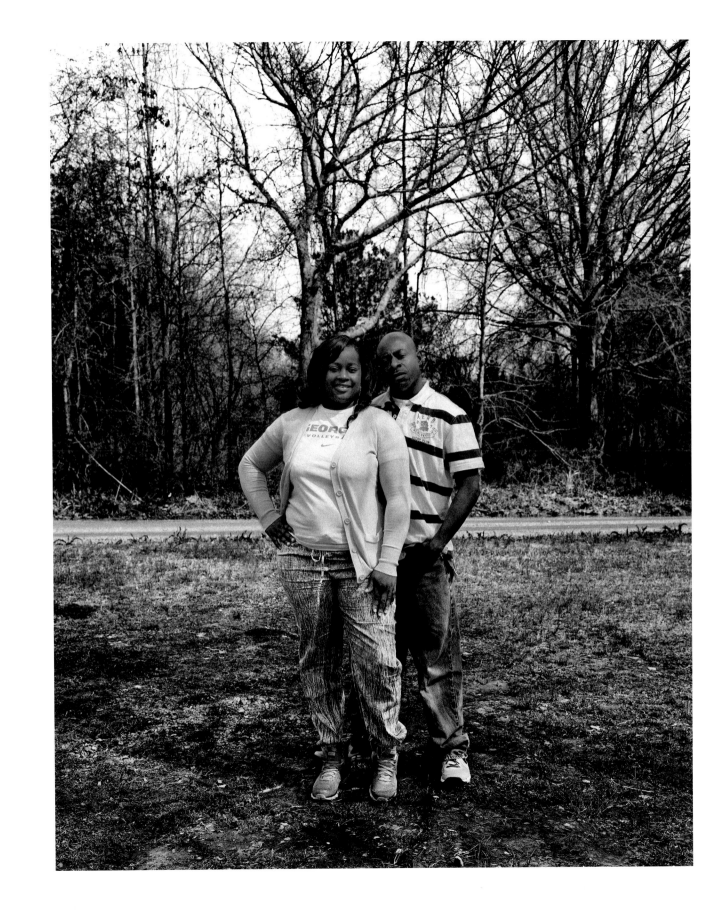

Paulena, Kennedy's niece, with her fiancé Anthony.

Anthony: "I am a welder, so I have skills if I don't have education. Frankly, it's hard to get good jobs around here if you are African American. People are pretty prejudiced. So we get them last and then we get the lowest pay."

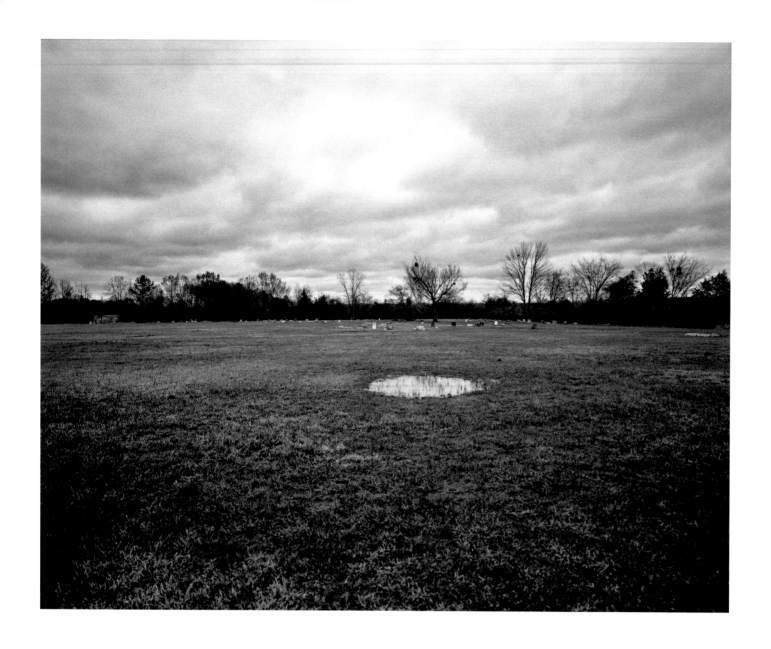

Charlie Brewer, Kennedy's father, is buried in this cemetery behind the family church.

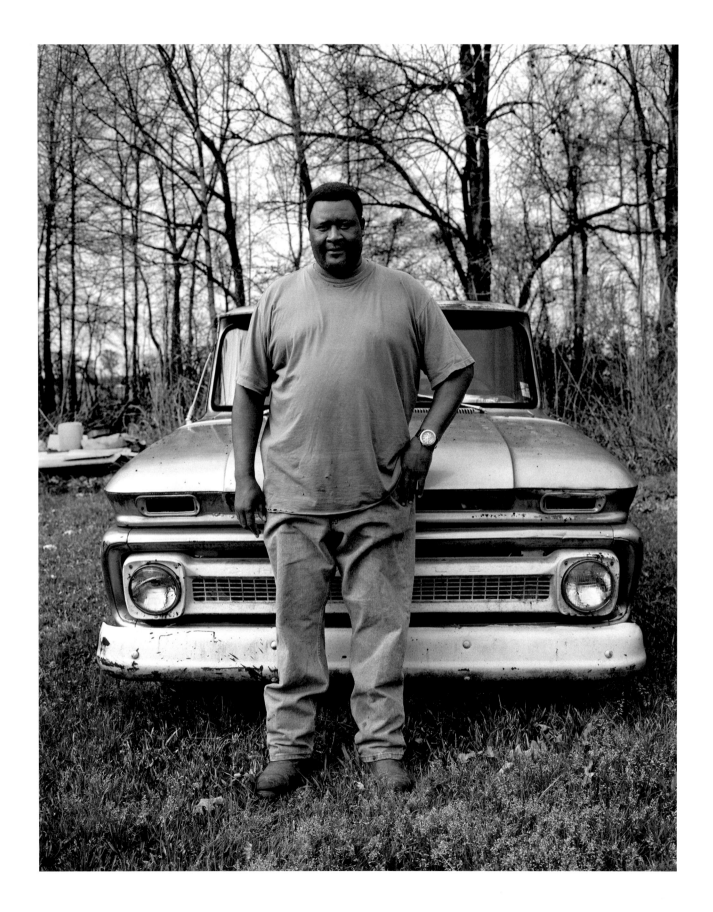

James C., Kennedy's brother: "I was sixteen when it happened for Kenny and I was shocked. It still needs a lot of changing around here, people are not treated fairly and the law is a problem. You can get pulled over for nothing, you can get accused of the wrong things. It's a pressure you feel because you have to be on your Ps and Qs all the time. You have to watch everything going on around you, you have to watch what you're doing, make sure you stay out of trouble, and you're doing nothing in the first place."

Josephine, Kennedy's sister, and mother to Kayla, Brittney, and Taresa: "I raised four daughters with my husband Ralph, who passed away recently. My heart broke for Brittney when she had Braxton because I had a daughter like him, she was sick for three years until she passed. But we are getting through it. You need a strong faith and we are a close family. We survived through prayer when Kenny got convicted. There was no respect for his life, they threw it away. It was hard. Some people close to us started to believe the newspapers and we were shocked. When it's your brother or father or son or mother, you won't be so quick to judge."

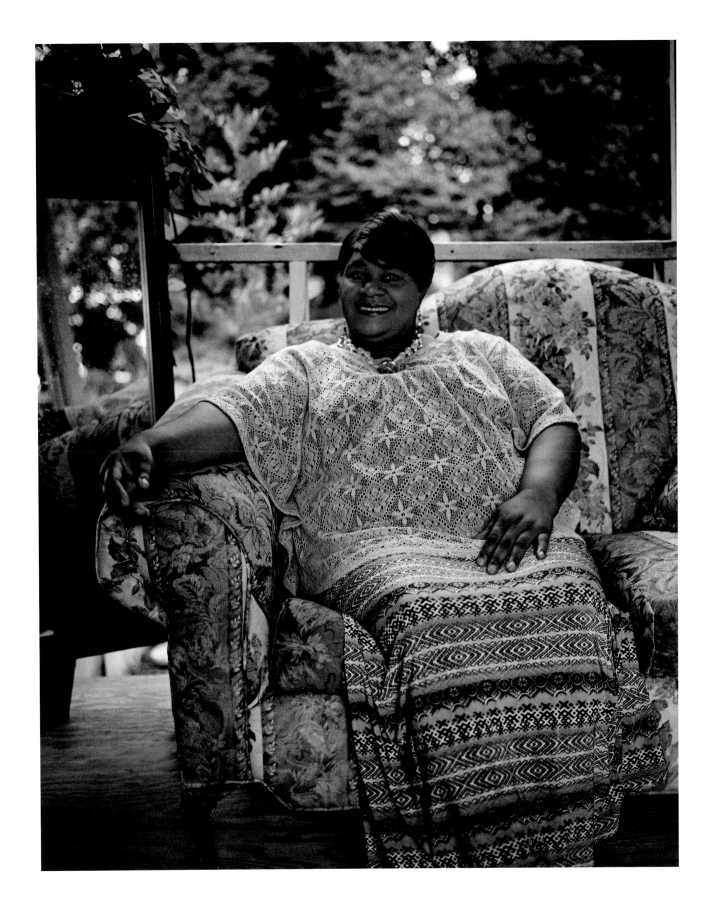

Brittney and her son, Braxton: "When Braxton was born, it broke my heart when they told me he had brain damage. He needs care 24/7 and is tube fed. He is four now and he is the most important person in my life. I would like him to enjoy things regular kids experience, he loves being around his cousins! But they say he will stay the same. There are no facilities here for Braxton and I would like to move to Atlanta. I'd have more help and time for me. But I love the country and my family. My mom is my biggest support."

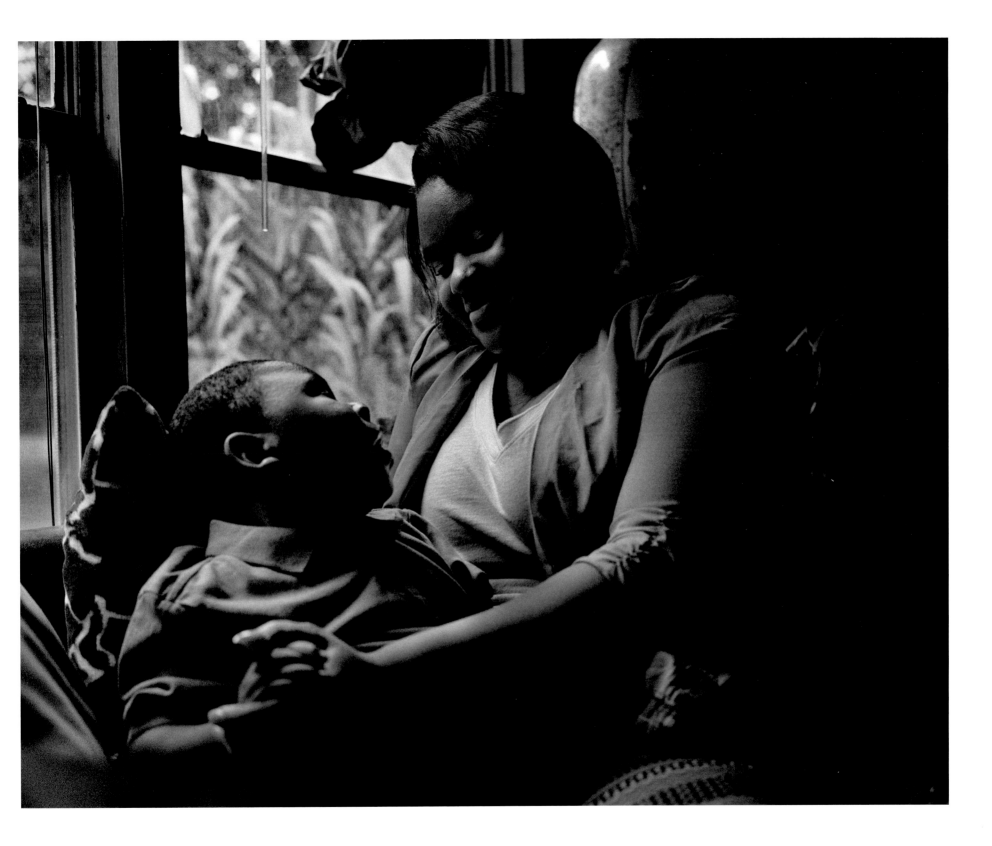

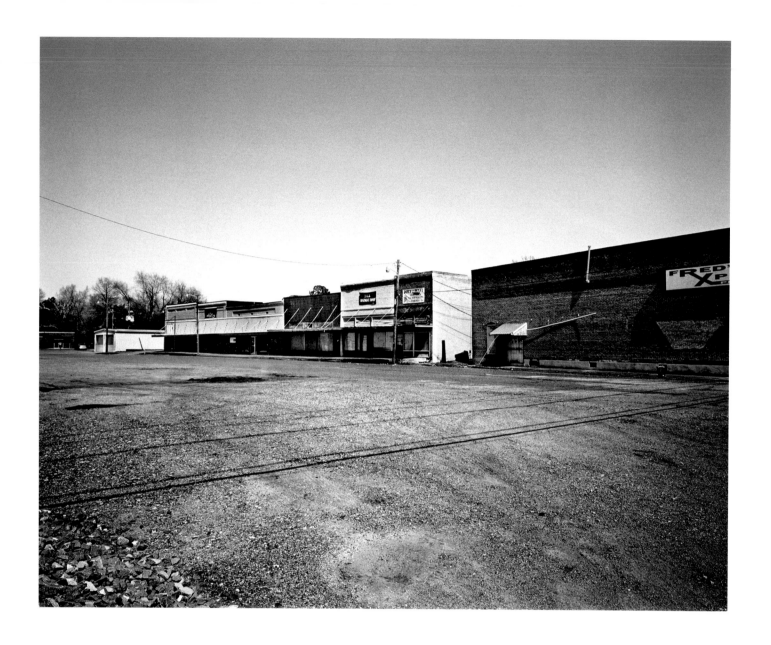

Downtown Brooksville by the railroad tracks.

Pem, Kennedy's brother: "We used to keep that little girl every weekend and that day she went missing, it was terrible. We knew something was wrong and were all looking for her. I went down and around the creek, looking everywhere for that little girl. Then Kenny got accused and I couldn't wrap my head around it. But we never lost hope. I like my life here, I've been married for twenty-two years and I have twin boys. I drive lumber. Family and friends and my job is what's important."

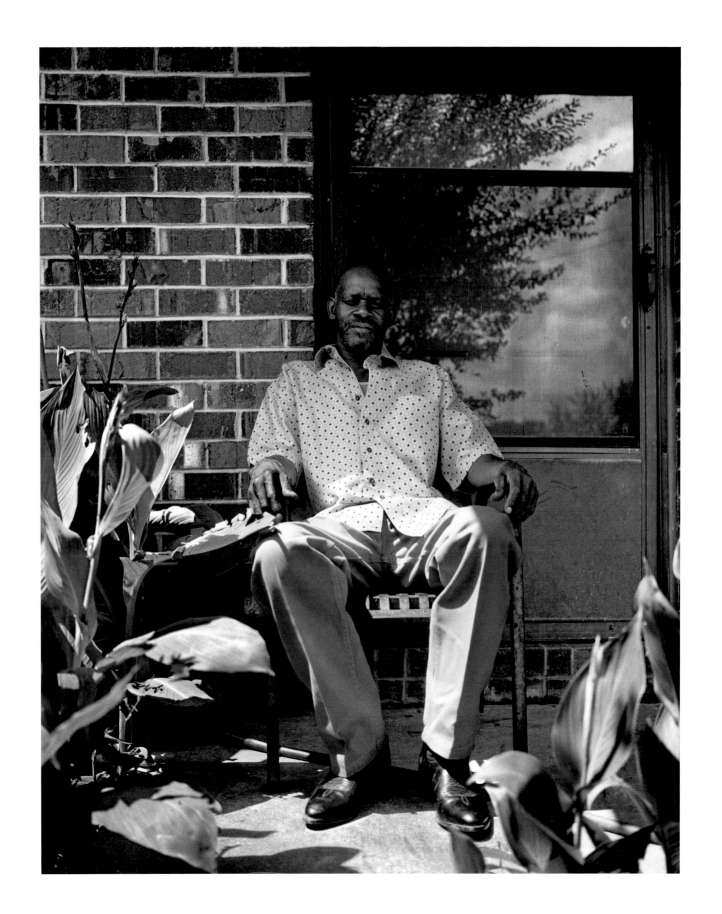

Twins Janeshia and Janaysha, Kennedy's great-nieces.

Janeshia: "I want to study nutrition to be a dietician and help my community. I'm also passionate about history since I realized that it was rewritten, and I want to make sure Black history is told truthfully. We haven't come as far as we think. Racism is a system, a structure put against an entire people to keep them from advancing. It hinders every aspect of your life from your health, your education, to your work. It keeps people separate, they don't want good people unifying in the fight against inequality."

Janaysha: "I can't wait to start college. I want to study nursing and my passion is to learn new things. I agree with my sister. People think we have equal opportunity but it's still the same struggle. It's not in your face when you are young, but it is as you grow up. We are not treated fairly, we are still dealing with police brutality, and they still walk free after murdering a black person. States now invest more in private prisons than in education, and we are the ones going to these prisons."

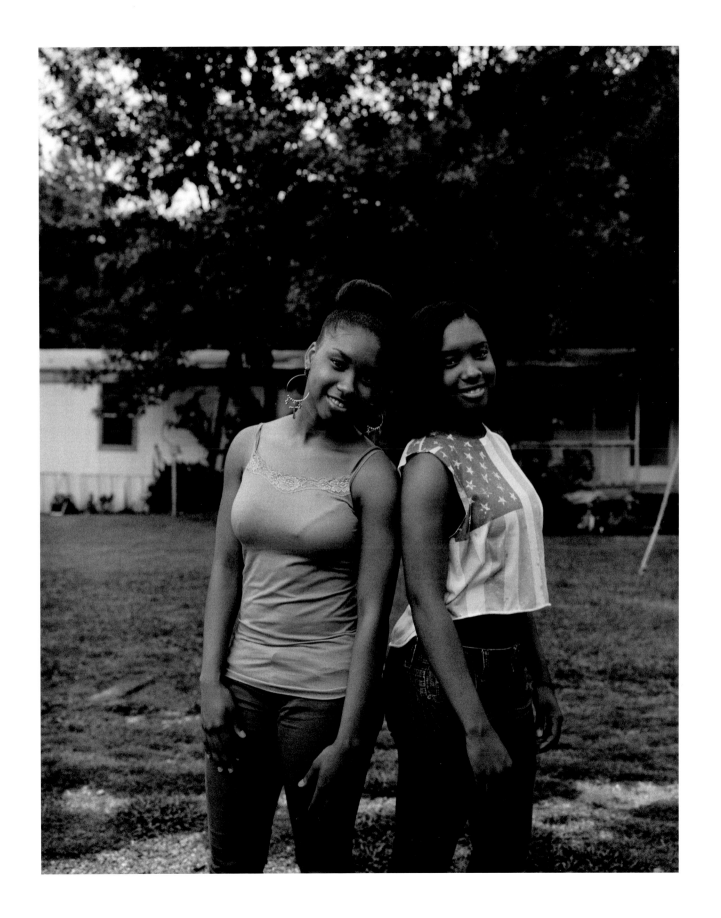

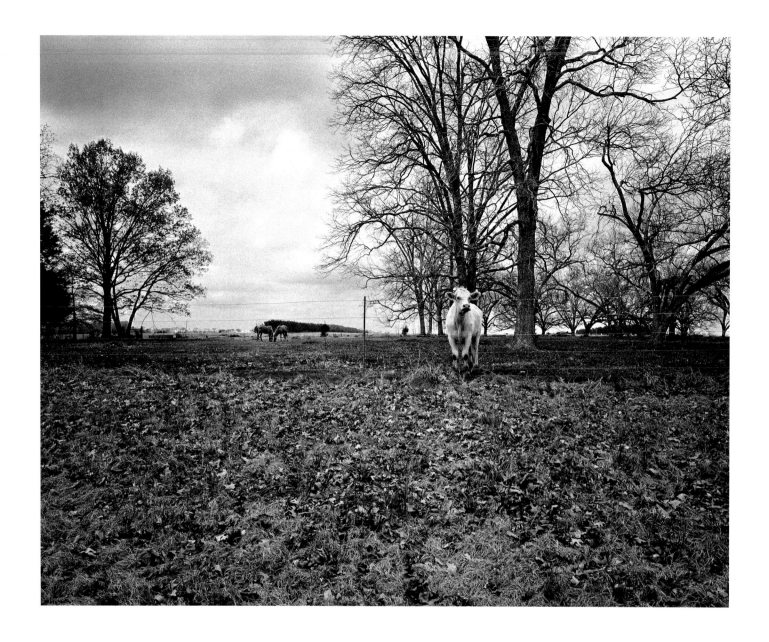

Highway 388, the road where Kennedy, mother Annie, sister Ruby, and other family members live.

Opposite: Martha and Ruby, Kennedy's twin sisters.

Martha: "There's still prejudice here and I am scared to drive by myself at night. I am scared of the police stopping me and me not knowing why. But I love the countryside, the peace and quiet. I'm content with my life, I'm very close to my family and I love going to church. I raised my three children and now I support them by taking care of my grandkids when they're at work. I take care of them every day and have them work hard on their homework because I don't think the schools are doing a good job."

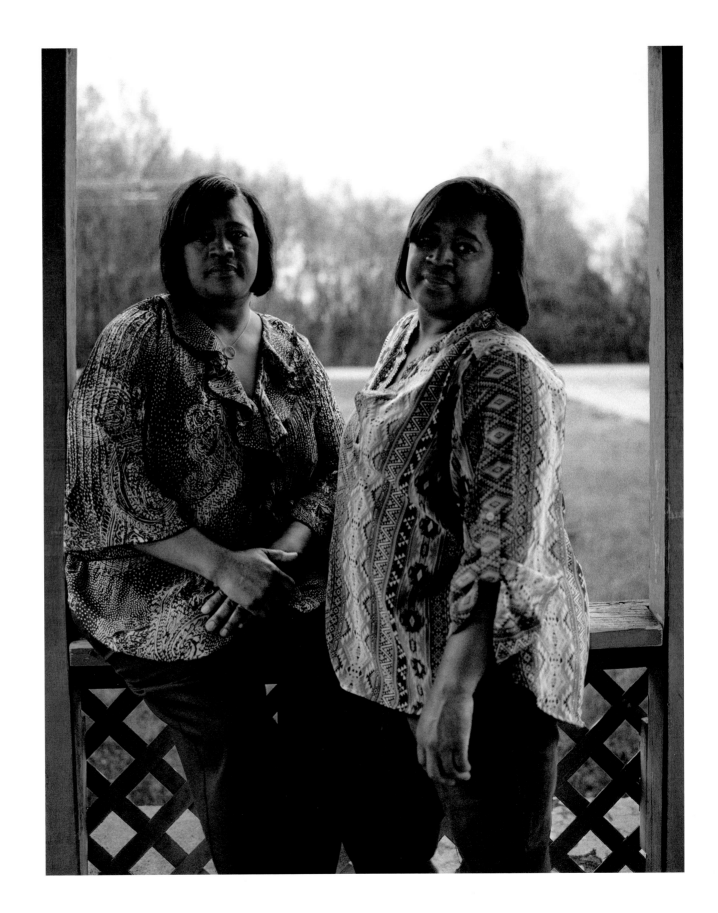

Ruby: "It was hard for our family when Kenny got convicted. I spent many nights asking God to protect him and keep him sane. It was also a big loss because we loved that little girl, I used to babysit her. I am so grateful that we have my brother home. I am the mother of four loving children and I have five grandkids. I love being with them and taking them to church. Growing up with fifteen siblings and not having much, has shown me life is hard, but if you trust in the Almighty God, it gets easier."

Roynika, Kennedy's niece, and her daughter Royshylia: "I am single now but I am very independent and if I get married one day, I want an equal partnership. I would do anything to take care of my two daughters and I work at the chicken plant for now. But I really want to be in law enforcement because I want a better life and more chances for my girls. There is no equal opportunity for African Americans here. Most white people are not friendly and are prejudiced. It's simple, whites only listen to whites. There's no real exchange."

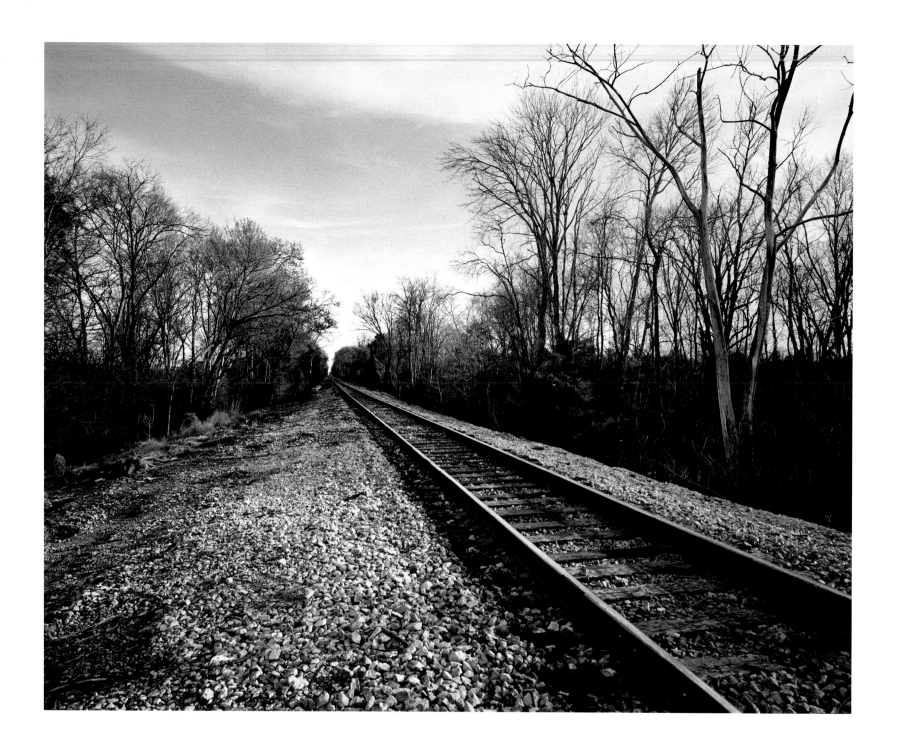

Train tracks in Artesia.

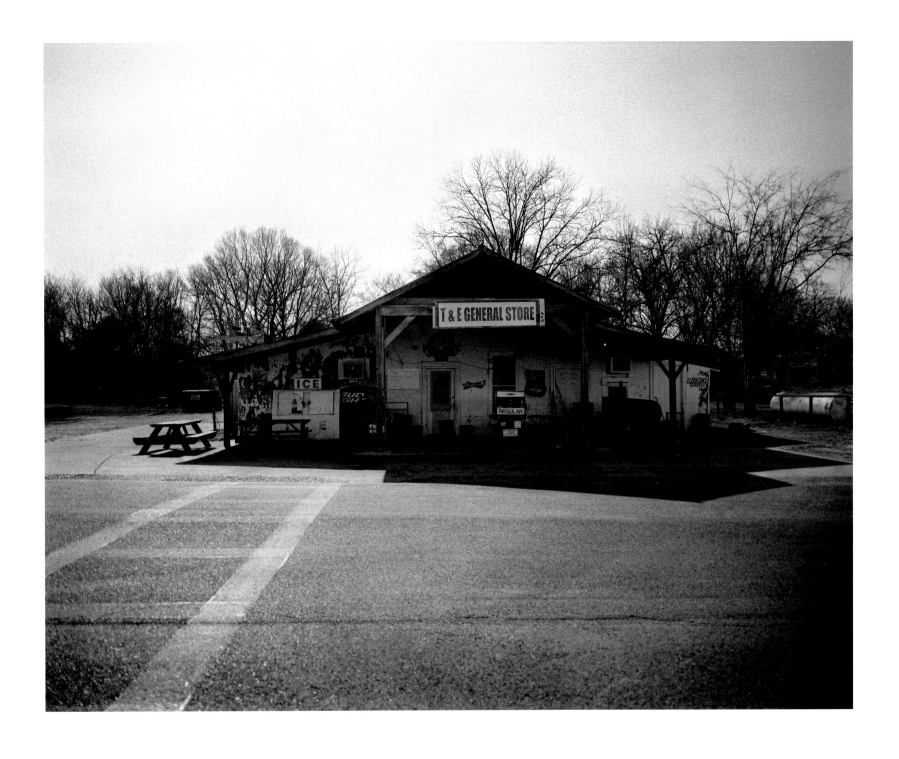

T & E General Store on Main Street, Artesia. The backroom turns into a dance club on Sunday nights.

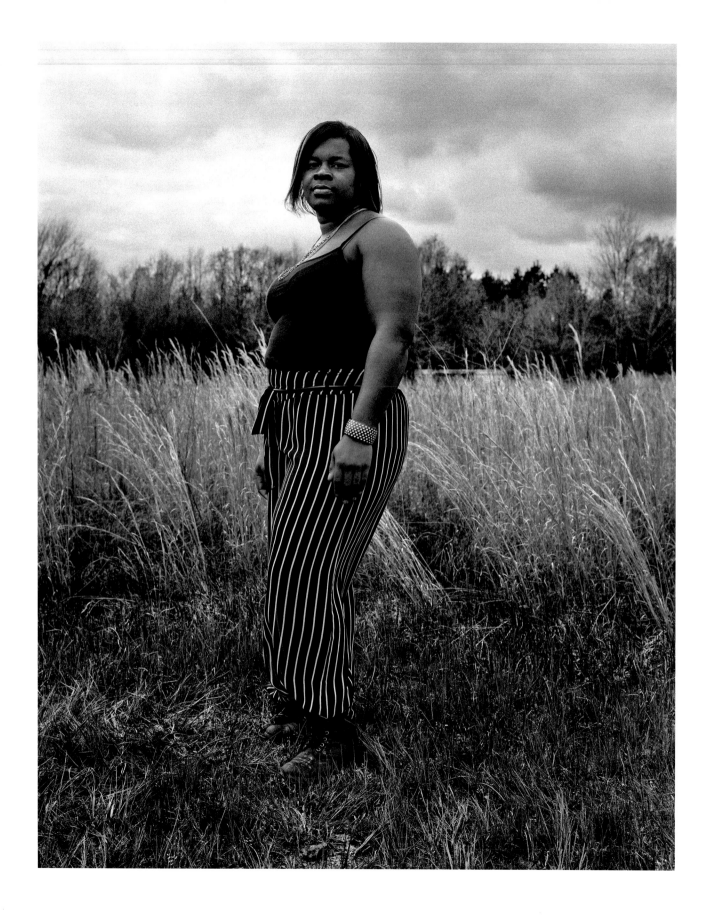

Marlene, Kennedy's niece and mother to Markeeta and Bryson: "There's not enough here for my daughter. I have a cousin in Florida, also with cerebral palsy, and now she's up and walking after therapy. Markeeta could improve and I'd like to move to a better city. When he's bigger, I also don't want Bryson out here with the violence, the drugs, and no opportunity. For things to change here, our communities need to vote more. That last prosecutor, who put Kenny away, was here for years. Black people knew not to vote for him, he sent people to jail for nothing."

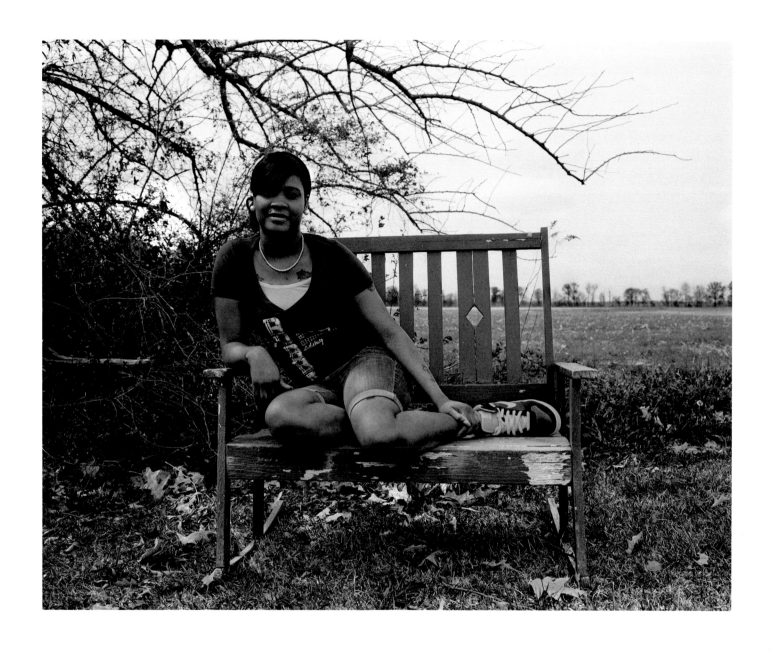

Nicole, Kennedy's daughter and mother to Chrishawn: "I have two little boys, one is a small baby but when he's bigger, I would like to go back to school to be a nurse. I like the country and I wouldn't move away from my family, but I wish there was more to do here and more diversity to meet different people."

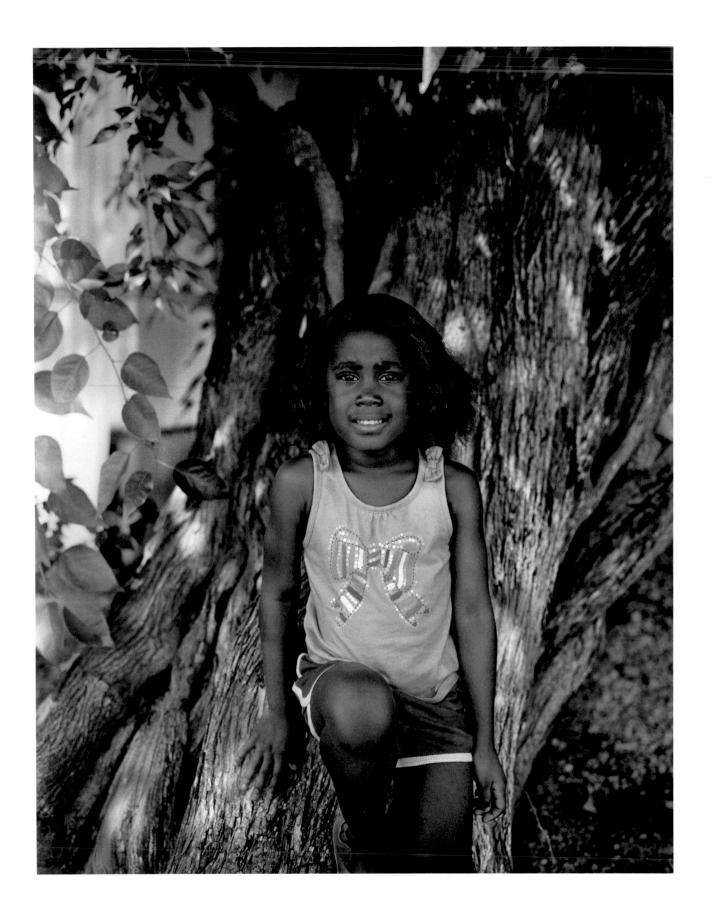

Azarion, 5, Kennedy's great-niece and Tedric's daughter: "I like to play soccer with my cousins. I like to read and I want to be a teacher or a doctor."

Cousins, left to right: Markeeta, Quindarious, R'nez, Azarion, Royshylia, Bryson, and Karli, Roynika's baby daughter.

Markeeta 13: "I just started high school and I love it. I love to read but I read a little less now because I'm so busy with all my friends."

R'nez, 5: "I want to be a policeman, a fireman, a football player and a wrestler! I like school and singing. I want to be in the choir at church."

Bryson, 6: "I want to be a policeman. Brooksville needs more police. I like school, sports, and singing. I want to sing in the choir, but for now I sing at home."

Karli, 2: "I want to be bigger and go on the school bus."

To delve into the Brooks and Brewer cases—to start at their beginnings—really means understanding that when it comes to Southern history "the present is a fleeting segment of the cumulative past."[2]

And so it is that the 1870 Noxubee County census listed 32 blacks with the last name "Brooks"; 35 with the last name "Brewer." Levon Brooks's family, as far as he knows, has always lived in or very near the county. Brooks and his brothers and sisters were all born and raised on a large, working farm in the eastern portion of the county where his mother and father and several uncles were employed for decades. Kennedy Brewer's mother, now in her mid-70s, says she and her family have been chopping cotton in or around Noxubee County for as long as she can remember. When asked how old she was when she began working in the fields, she answers matter-of-factly: "Just old enough."

Noxubee's fields are located almost at the exact center of the Black Prairie Belt, an area that the first European explorers extolled for its "extensive and fertile savannas" that produced from its rich soil each season "grass with its seeded tops as high as our heads, when on horseback, and would very likely bear mowing, three or four times in one season."[3] By the 1830s, once the Prairie's earliest-known residents—the Mississippi band of Choctaws—were forcibly relocated to the Indian Territories in Oklahoma, settlers quickly moved in and quickly began to cultivate the rich soil. Almost all of it was planted in cotton, and it immediately became the region's primary cash crop.

Within the first three decades of the 1800s, Mississippi counted a slave population of slightly more than 65,000. Three decades later—on the eve of the Civil War—the number had ballooned to 436,631. Noxubee County's share was 15,496 slaves, almost three times the size of its white population of 5,171. Slave wealth was concentrated among a relatively small portion of white landowners: 138 whites in the county owned more than 40 slaves apiece.

Even though Emancipation and the end of the Civil War ended slavery as an institution, they also marked the commencement of a decades-long effort to salvage the region's social and economic structure that was based on cheap, expendable labor. In 1865, Mississippi's newly elected governor, Benjamin G. Humphreys, called a special session of the state legislature to discuss what he termed the "negro problem." His solution, quickly adopted by the state legislature, was the "Black Codes"—a series of draconian laws that co-opted the criminal justice system as a means to enforce *de facto* slavery. Instead of ensuring justice, they traduced it by providing free—inmate—labor. It was all done under the color of state law. The reign of terror would last for nearly a century.

"The Mississippi Plan," as it became known, achieved its apotheosis in Noxubee County. Within a few years of its implementation, Noxubee, along with several other counties in central east Mississippi, came to the attention of the United States Congress because of concerns that the recently ratified Fourteenth Amendment and its civil rights guarantees were being ignored. Congress convened a joint select committee to investigate and produce an investigative report. "In the latter part of 1870, and during the early months of 1871," one of its witness observed, "the Ku-Klux organization began to be very active" and committed "numerous murders and whippings, the character and atrocity of which, and the motives assigned for them, correspond with the deeds and declarations of the organization in other States." Incidents in Noxubee—"the whipping of men to compel them to change their mode of voting, the tearing of them away from their families at night, accompanied with insults and outrage, and followed by their murder"—15 according to witnesses—were by far the worst of the incidents in "the affected counties." By 1875, E.D. Cavett, a local white citizen, claimed the county had "redeemed ... [itself] from Radical [Reconstruction] rule ... [and] cut out the heads of all the drums owned by negroes and not a radical drum has been heard in Noxubee County since that date."

For much of Southern history, black victims of crime and black perpetrators did not arouse much interest from law enforcement. As the [Jackson] *Clarion Ledger* reported in 1904: "We had the usual number of [Negro] killings during the week just closed. Aside from the dozen or so reported in the press, several homicides occurred which the county correspondents did not deem sufficient to be chronicled in the dispatches." But when the call came in to the Noxubee County sheriff's department to report Courtney Smith's disappearance—the victim in Levon Brooks's case—it was a different era.

The Brooksville police department did not hesitate to act. It immediately dispatched its burly, white chief, Cecil Russell, to the scene. Russell was in his 16th year of service. He arrived in a matter of minutes. Russell joined the volunteers and directed them to split into smaller search parties. When it grew dark, he called off the search, but instead of leaving, he stayed and dozed in his car so that he'd be close by if something developed.

It was Russell, who before the search party re-formed the next morning, woke and walked to the small pond. It sat behind an embankment that was covered in small trees and brush. Veteran intuition told Russell to look again in the morning light. By the time he had waded in, floated Courtney's body to the edge, and pulled it onto

the bank, another police officer had arrived and stood watching. He wore a field jacket against the morning chill. Through the thin stand of trees, the two officers could hear car doors opening, and people talking as they began to gather for the search. Russell asked the officer for his jacket. He then took one last look at Courtney Smith and did the only thing he could think to do: he knelt down beside her and gently draped the jacket over her tiny body.

Earlier that morning, Robert William, a local deputy sheriff responsible for interviewing children who were victims of, or witnesses to, criminal acts, had spoken with Ashley Smith, Courtney's sister. During their conversation, Ashley identified Brooks, with whom she was acquainted because he and her mother were friends, as the individual who had come into the house. Brooks was taken into custody.

Dr. West arrived at the Rankin County morgue to meet with Hayne the day after Hayne had conducted his autopsy. As Dr. Hayne would later explain in his trial testimony, his determination to associate the forensic odontologist, Dr. West, was based not only on his own suspicions about the marks, but on West's impeccable credentials. West had recently been named researcher of the year by the American Academy of Forensic Sciences. Not only did he have a thriving clinical dental practice in Hattiesburg, but he was also engaged in ground-breaking forensic bite-mark research that used alternative sources of light to reveal bite injuries that would otherwise remain invisible during routine post-mortem examinations.

Courtney's body had been embalmed at that point, but not yet buried, and West examined the wounds on her wrist and body. After photographing them, he excised the affected tissue so that he could compare the tissue samples to the enhanced photographs— and then to the dental mold. West's technique of comparing the molds to the bite marks was a multi-faceted process. According to the explanation that he provided at Brooks's trial, he began "with large parameters and worked … [his] way down." First, he determined the orientation of the person who was bitten (in this case Courtney) to that of the person doing the biting (Brooks). That way, as he explained, he could better determine the anatomical properties of the wound site—was the skin, based on the positioning of the victim and biter—taut, loose, or something else? Having accomplished that, he was in a better position to determine the dynamics that occurred "when the teeth grab[bed] into the skin and pull[ed] across it." Based on his expertise, West determined that the perpetrator had been positioned in front of Courtney and had bitten down on the top portion of her forearm, just above the wrist.

With respect to the teeth comparisons themselves,

> [t]he first thing … [West looked for was whether] the size of his arch [was] consistent with the pattern that you see on the wound. Then you look at … the shape of … [the] arch consistent with the size or shape of the pattern. Then you start going down looking at individual teeth …. Are the teeth close together, are the[y] spaced out apart, is one tooth turned crooked or is it lined up properly and as you go down these steps you eliminate individuals …. You look for things like flaws in the tooth. Was it chipped or broken, cracked[?] Does it have a sharp edge[?] Does it have a blunt edge[?] … Is there something unique about this tooth that represents itself in the bite mark pattern[?][4]

Usually, when West studied bite marks caused by adult mouths, he was able to study the markings created by the teeth that stretch from eye tooth to eye tooth, six in all. But West noted several difficulties with the analysis of the marks on Courtney's body. Because she was a small child, the adult who presumably bit the portion of her wrist was not able bite down on a surface large enough to have all six teeth leave a mark. The bite marks that West was using as points of comparison were according to his observations caused by "only…two teeth." Because he recognized "the gravity of the situation—we're talking about a murder investigation," West wanted to make "doubly sure that it was these teeth and only these teeth." As he sat down in his office to work with the molds that he had taken from the suspects arrested by the Noxubee County Sheriff's Department, he worked first with the arches. Most of the molds he was quickly able to rule out. But with one of them, even though the entire arch was not present at the wound site because of the site's limited size, West was still able to note a consistency between the arch of the model and the arch at the wound site. He was also able to hone in on two of the incisors—the front cutting teeth. He observed immediately that the cutting edge of the incisors had distinctive markings—"fractures and bevels"—and one tooth that had a "scalloped out area with a sharp edge." He was also able to document consistencies and precise matches between the wound and the size and spacing of the teeth.

Finally, as he would explain at the trial, because of his fidelity to his vocation and his recognition of the seriousness of the case, he went "the extra mile on this one." On the one hand, he explained, he was cognizant that his expert opinion could likely "cost a man his freedom." But, separate and apart from that, such an opinion, if wrong, might also "allow an individual to still be loose in the community." "For my own satisfaction" he said, "[I] look[ed] for some minute details … minor marks that could only be attributed to … [this particular

individual's] teeth so I could lay this thing to rest."

To do that, West used a forensic diagnostic tool that he had invented himself: the use of ultraviolet light combined with precision photography to locate, enhance and compare wound markings that would otherwise remain undetected under normal practice. As he described the process, human skin tissue that has been abraded—cut or crushed by a bite mark—absorbs ultraviolet light, unlike undamaged skin, which does not. When UV light is shined on an area like that, the contrast between the damaged and undamaged skin is increased and, with proper observation, the comparison is easier to make. After employing the technique in the case, West was firm in his professional opinion that "it could be no one but Levon Brooks that bit this girl's arm."

In Brewer's case, West began his examination of Hayne's initial findings by comparing the unique features present in the marks on Christine Jackson's body to the unique class and individual characteristics that he could identify in each of the separate suspects. Class characteristics, as West described his experiences with them in his forensic research, were characteristics found in a certain specific group of objects. He often analogized by comparing a box of flat head screwdrivers to a box of Philips-head screwdrivers: though each of the Philips-head screwdrivers may be different sizes, they all display the same class characteristic—a Philips-head shape—which distinguishes them from flat head screwdrivers. According to West, these same class differentiations are observable in individuals' dentition—in the arch, the shape of the jaw, overbites, underbites, and so forth. Even an individual tooth, he explained, may sometimes exhibit class characteristics.

Individual characteristics, on the other hand, West explained, usually occur from "random wear and tear"—things like chipped or broken teeth. Though these individual characteristics are not always obvious, even small cracks or other imperfections can create visible differences on the biting surface. West also considered additional factors: the relative positioning of the biter and the person being bitten—in this case Christine—the likely reaction of each during a violent struggle, or the elasticity, or lack of it, in the skin at the site of the bite.

His analysis revealed that 5 of the 19 bites were "very good bite marks;" the remaining ranged from "fair to average—or poor." All of them, though, West concluded, matched Brewer. On May 14, just over 10 days after Christine had disappeared, West wrote a letter to Noxubee County law enforcement that summarized his findings: the "bite marks found on the body of Christine Jackson were indeed and without doubt inflicted by Kennedy Brewer."

Brooks's appeal was written and filed by one of his trial attorneys. The only issue of merit involved West's testimony. Having grown weary of what it viewed as baseless challenges to bite mark evidence, the State Supreme Court not only affirmed Brooks's conviction but also took the time to "state affirmatively that bite-mark identification evidence is admissible in Mississippi."

After Brewer's appeal was filed, the Mississippi Supreme Court finally found "no error in the trial of this matter that necessitates a reversal or any other ground upon which Brewer is entitled to relief from the conviction or the sentence of death by lethal injection." Brewer appealed to the United States Supreme Court, which, presumably because it found no error, declined to hear it. Two days after the Supreme Court denied his appeal, Mississippi sought permission to re-schedule Brewer's execution date.

For all intents and purposes, Levon Brooks's fight was over. The Sixth Amendment right to counsel does not provide a lawyer for post-conviction claims, so any challenge would have to be drafted by Brooks himself. That kind of legal training is beyond the ability of most attorneys. Levon Brooks didn't even try. Instead, he settled in to serve his life sentence. He honed his self-taught artistic skills and drafted homemade greeting cards that he sold or traded to fellow inmates and dwelled on his mother's parting advice: "You go on up there and do right, and the Lord will bring you home."

Brewer wrote to his lawyer. "[C]ould you send me about $60.00 to get me a type writer[?]" he asked. "[W]hat I am doing is fixing to get involve in learning the law because I just can't spend my life in prison for nothing that's why I try to learn more about the law each day." His lawyer never sent him one, so Brewer pulled out a clean piece of lined notebook paper and wrote a letter. He addressed it to an organization that he had heard about in the back of a magazine. "Dear Mrs. Greene," he began in careful script, "how are you today? I know you probably don't know me but the reason am writing is can you … help me out concerning my case … I really, really, really would highly appreciated."

Four days later, Brewer's letter arrived at the Innocence Project in New York.

After Innocence Project lawyers asked that DNA from Brewer's case be tested, the request was granted, and in the late fall of 2007, Noxubee County law enforcement sent several boxes of physical evidence to a lab in California. The evidence included material from Brooks's case, too, because Brewer's lawyers were of the mind that the true perpetrator had likely committed both crimes. The lab began its testing on

the semen from Brewer's case and quickly identified a single profile—a profile that did not match Brewer. That wasn't enough for the prosecution, however. Because he remained convinced of Brewer's involvement, it was imperative that the source be identified, if at all possible.

The cheek swabs taken from the suspects in Brewer's case were still testable. So the lab went to work on those. After locating useable DNA, the analyst, Dr. Edward Blake, began his analyses. "Part of my role in the investigations is to take the data and go through and analyze it and inter-compare the samples," he explains. "And so, I'm sitting at my computer and I'm going through this data, and—can I use a four-letter word?—I'm sitting at my computer and I'm going 'Holy Shit!' we've identified the sperm source. It's Justin Johnson."

When Brewer's attorneys were notified of the results, they kept the news from the prosecutor and Noxubee law enforcement, both of whom had a vested interest in defending the integrity of their investigations and prosecutions, and turned instead to the Mississippi Attorney General's office for help. Investigators traveled from their offices in Jackson to Pilgrim's Rest and turned left about a half mile after passing Kennedy and Gloria Jackson's old house. Less than a quarter mile later they pulled up beside a small, dark green cottage. Some of the agents covered the rear of the house while two others knocked on the front door. Justin Johnson answered. After being confronted with the DNA test results and placed under arrest, he agreed to return with the investigators to the crime scenes.

At Brewer's old house, he showed them how he had walked up to the bedroom window, quietly opened it and reached in and taken Christine, sexually assaulted her, strangled and thrown her, still alive, into the creek. He admitted driving his car to Brooksville and parking near the pond. He described walking to Courtney's house, through the unlocked door, past the sleeping figure of Courtney's uncle, and into the bedroom. He had acted alone, he said. He didn't know Levon Brooks or Kennedy Brewer. He didn't bite either girl. So much for bite mark science and for Dr. West's groundbreaking analyses.

Discovering the quantity and quality of evidence necessary to exonerate someone typically takes years, if it comes at all. Given the age of many potential wrongful-conviction cases and the vagaries of physical evidence—mainly its storage and degradation—the death or disappearance of witnesses, their diminishing memories, combined with procedural difficulties that arise in a post-conviction setting that values finality, each exoneration is in its own way a minor miracle. In Brooks's and Brewer's cases, however, the dispositive results of the DNA testing along with Johnson's unequivocal confessions forced the State to drop any opposition and the cases moved to a conclusion

rapidly. Brewer was exonerated in Noxubee County Circuit Court in February, 2008. Levon Brooks a few weeks later—in early March. Together, the two had spent almost 30 years imprisoned for crimes that they did not commit.

A recent study by the American Bar Association showed that 80% of respondents, representative of national race and gender demographics, agreed with the following proposition: "[I]n spite of its problems, the American justice system is still the best in the world." That view is understandable. On the face of it, our criminal justice system is replete with guarantees that are the envy of much of the world.

Take *Gideon v. Wainwright* for example.[5] It is commonly and correctly understood that the case stands for the right to the assistance of a lawyer in a criminal trial. *Strickland v. Washington*, *Gideon*'s appellate counterpart, is supposed to ensure *Gideon*'s promise by affording rigorous review of the *effective* assistance of the counsel when a convicted defendant appeals his trial counsel's performance.[6] As a concept, *Gideon* was in full force in Brooks's and Brewer's case. They were each immediately appointed lawyers who showed up and acted the part. One could argue that much of the blame—maybe most of it—for Brooks's and Brewer's wrongful convictions falls other than on their defense lawyers, but their lawyers' role was certainly a key component and, maybe more importantly as a fundamental, equitable matter, their lawyers were really not present in any meaningful way.

Leaving aside the reticence of reviewing courts to grant convicted prisoners' *Strickland* claims, Justice Thurgood Marshall, who dissented in *Strickland*, anticipated the practical difficulties that reviewing courts would face in determining whether there had been constitutional error on the part of trial counsel:

> [I]t is often very difficult to tell whether a defendant convicted after a trial in which he was ineffectively represented would have fared better if his lawyer had been competent. Seemingly impregnable cases can sometimes be dismantled by good defense counsel ... The difficulties of estimating prejudice after the fact are exacerbated by the possibility that evidence of injury to the defendant may be missing from the record precisely because of the incompetence of defense counsel.[7]

His observations were precisely the difficulty that Brooks's and Brewer's trial lawyers created and that their appellate attorneys would have had to overcome if they had raised claims of ineffective assistance of counsel. Assuming that they had even raised them, Brewer's lead

appellate lawyer, who has probably been sanctioned by the State Bar more times than any other lawyer in the modern era, was hardly the type to raise the issue or undertake the necessary investigation to support it. In Brooks's case, raising a claim would have required Brooks's lawyer to fall on his sword: his trial lawyer and appellate lawyer were one and the same.

In fact, in the close to 30 years since *Strickland*, findings of ineffective assistance of counsel have been extraordinarily rare, and, as far as Supreme Court cases on the subject are concerned, nearly nonexistent. In all of the criminal cases that the Court has been asked to review—not including those involving murder charges—where ineffective assistance of counsel was the main issue, the Court has refused consideration. In capital cases, the Supreme Court has ruled defense counsel's conduct ineffective only three times. Criminal defense in this country is almost exclusively *indigent* criminal defense, and so the Supreme Court's *Strickland* admonitions fall almost exclusively on poor criminal defendants who are at the mercy of lawyers whose trial skills are, like Brooks's and Brewer's lawyers, grossly deficient but still presumed to be sound.

The likelihood of any court granting Brooks or Brewer relief from their convictions based even on a claim of actual innocence was distressingly thin. To begin with, after *Herrera v. Collins*,[8] most post-conviction exonerees never even raised a claim of innocence because doing so seemed fruitless. The Supreme Court has denied 30 petitions for *certiorari* filed by actually innocent exonerees. In one case, Larry Youngblood's, the Court granted certiorari but denied relief for his claim that law enforcement had failed to properly preserve biological evidence that could, if tested, have proven his claim of innocence.[9]

Youngblood had been charged and convicted for the abduction and rape of a ten year-old boy from a carnival grounds in Pima County, Arizona. The boy was taken to a hospital where semen samples and his clothing were collected as evidence. Based on the victim's description of the assailant as a man with one disfigured eye, Youngblood was charged with the crime. Youngblood maintained his innocence, but no forensic testing was conducted on the evidence because the police had improperly stored the evidence and allowed it to degrade. Youngblood was convicted and sentenced to a lengthy prison term.

On appeal, Youngblood argued that he should be allowed post-conviction testing because an expert witnesses at his trial had testified that, had it been stored correctly, test results on the evidence might have conclusively demonstrated his innocence. The Court disagreed. Absent bad faith destruction of evidence, the Court wrote, law enforcement had no duty to preserve evidence in criminal prosecutions. In

Youngblood's case, the "failure of the police to refrigerate the clothing and to perform tests on the semen samples can at worst be described as negligent."

Not only did the decision affect Youngblood, but it offered no incentive for law enforcement to adopt procedures to ensure preservation of critically important evidence. Fortunately for Youngblood, in 2000, at the request of his attorneys, new DNA technology permitted the testing of the damaged evidence. The results exonerated Youngblood, and he was released. Early the following year, the DNA profile that had been generated was found to match the DNA profile of Walter Cruise, who, blind in one eye, was then serving time in Texas on unrelated charges. In 2002 Cruise was convicted of the offense and sentenced to twenty-four years in prison.

For me, it is the broader context of the Brooks and Brewer cases that holds the most resonance. Brooks's and Brewer's lives spanned some of the most turbulent and troubling incidents in our nation's history, as well as the efforts—and successes—that envisioned something far different and better. The prediction that Levon Brooks, born in 1959 in a tenant shack on a plantation overseen by one of Mississippi's most strident racists, would one day be caught up in the criminal justice system would not have been a surprising one. The prediction that his arrest and prosecution would have comported with the Constitution—that his trial would have been full and fair, and not only deracinated but judged by a jury of his peers who themselves had made momentous personal sacrifices to sit in judgment—that would have seemed a long shot. But it happened. For Brewer, too.

Yet, the echoes of the past are impossible to ignore, and the end result different only by degree. Though neither Brooks nor Brewer was paraded from the county jail and hung from the nearest tree, the remainder of their lives, and in Brewer's case his scheduled execution, were the result of sanctioned and deliberative process action. In that way, the difference becomes largely one of semantics, or perhaps worse, because what happened to them occurred inside and with the blessing of—and not outside and without—the legal system.

Recent discussion and scholarship—some of it very contemporary—have employed the term "Jim Crow" to describe today's criminal justice system and its disproportionate effects on blacks. In her book, *The New Jim Crow: Mass Incarceration in the Age of Colorblindness*, Michelle Alexander argues that "mass incarceration in the United States...[has] in fact, emerged as a stunningly comprehensive and well-disguised system of racialized social control that functions in a manner strikingly similar to Jim Crow." Alexander describes not just the sheer numbers of incarcerated individuals in this country, and the

disproportionate jailing of blacks, particularly for drug offenses where virtually every study indicates that whites commit a far larger portion of criminal drug offenses, but she also makes a good case for what she refers to as the "birdcage" metaphor to make clearer the extent of the destructive effects. That cage consists not simply of the incarceration itself, but also includes the cascading series of collateral effects that consign individuals caught in the criminal justice system to a lifetime of second-class citizenship.

Take, for example, the right to vote, serve on a jury, remain eligible for health and welfare benefits, qualify for public housing, student loans, or a host of even subsistence-level jobs. Each of these—some of which are so basic to our ability to survive in the world, much less establish the basis of a productive life—are effectively placed beyond the reach of anyone with a criminal record. These collateral consequences are not enumerated in state or federal criminal codes, but they are in many ways more damaging than the statutorily prescribed sentence for the underlying offense.

Alexander is not wrong about these consequences and their debilitating effects on all of us. However, referring to the era and effects as "The New Jim Crow" is too atavistic. It mostly misses just how pernicious and cynical the system has become. Though current state and federal criminal codes have become increasingly punitive, both in the conduct they cover and law enforcement's prosecution of them, there is nothing dishonest in their purpose or the justification for public policy supporting them. This is true even though there are strong arguments to be made that certain criminalized conduct and the enforcement of it have a disproportionate, likely even discriminatory, effect on certain groups, particularly blacks.

The mechanisms that worked to ensnare Brooks and Brewer, though, were in many ways the opposite. They were envisioned as part of a multi-faceted effort to defeat inequality and to make equal justice a reality for all. On the surface, they did that. They were the reason why Brooks and Brewer both received appointed counsel; why no one referred to them as "niggers" during the trial; and why they received appellate review of their convictions. They were also why each was indicted and then judged by a jury of their peers; why the verdicts were the result of true and honest deliberation as opposed to simply a bigoted effort to ensure the status quo.

However, on another level, these things are nothing but falseness and absurdity. Brooks was convicted of a crime that he did not commit. A homicidal pedophile remained at large in the community long enough to assault other victims and murder Christine Jackson, a crime that Kennedy Brewer nearly paid for with his life. The juries in both

cases, in some ways the physical embodiment of so much that has gone right with race and class in a place that for so long had been a place where everything had gone wrong, walked out of the courthouse after their service believing that they had participated in rendering just verdicts. They hadn't. Worse, they were complicit in a contemporary version of the same old story. In other words, these things that we believe are hallmarks of fairness and guarantors of justice, that we rely on to ease our consciences and justify our actions, are in reality employed to mask a much more sinister effort: the cynical manipulation of what were once true gains in due process and equal protection into measurable false promise and palpable human tragedy. Over time, the efforts to rid the system of bias and bigotry—of "Jim Crow"—have been used instead to mask the fact that they are now built into its very structure and doctrine.

And yet, because we define ourselves as a society that values fairness and decency, the specter of a wrongful conviction remains at some fundamental level deeply disturbing to us. No matter what a majority of the Supreme Court or its adherents might say to rationalize, innocence cases, wrongful convictions—and the processes that caused them—are not us. At some point, we will no longer find it intellectually honest to arrogate to ourselves the false comfort that comes from believing simultaneously that ours is a system of justice unmatched in its guarantees of fairness, with our sincere concern and sympathy for people like Levon Brooks and Kennedy Brewer. But until we get to that point, the prominent players in these cases will continue to produce this peculiarly American brand of justice, day after day, case after case. The innocent and guilty will suffer alike, the circle of victims will continue to grow larger, and our rationalization will grow more complex. There will be no reckoning and no accountability. Or, to the extent that there is, it will be the kind that exists here: Of all the people who were involved, the one who has the most at stake—his life—is the only one who has come clean. When law enforcement officers surrounded Justin Johnson's house in early February of 2008, he identified himself and admitted to being the perpetrator in both cases.

1. Associate Professor of Law & Director of the George C. Cochran Innocence Project, University of Mississippi School of Law. This excerpt is from the article by the same name, originally published with a complete list of sources in the Georgetown Journal of Legal Ethics, Vol. 28, No. 123 (2015) and re-published here with permission.

2. C. Vann Woodward, The Burden of Southern History 37 (Louisiana State University Press 2008) (1960).

3. John A. Barone, *Historical Presence and Distribution of Prairies in the Black Belt of Mississippi and Alabama*, 70(3) CASTANEA 170, 1 (2005).

4. Brooks trial transcript at 721–722

5. Gideon v. Wainwright, 372 U.S. 335 (1963).

6. Strickland v.Washington, 466 U.S. 668 (1984) (Marshall, J., dissenting)

7. Strickland v. Washington, 466 U.S. 668 (1984).

8. Herrera v. Collins, 506 U.S. 390 (1993). *Herrera* asked a simple question of the Supreme Court: "whether the Eighth and Fourteenth Amendments permit a state to execute an individual who is innocent of the crime for which he or she was convicted and sentenced to death." Chief Justice William Rehnquist, writing for the majority determined that the execution of an innocent person, fairly tried, would not offend any fundamental principle of justice "rooted in the traditions and conscience of [the American] people." *Id*. at 411.

9. Arizona v. Youngblood, 488 U.S. 51 (1988).

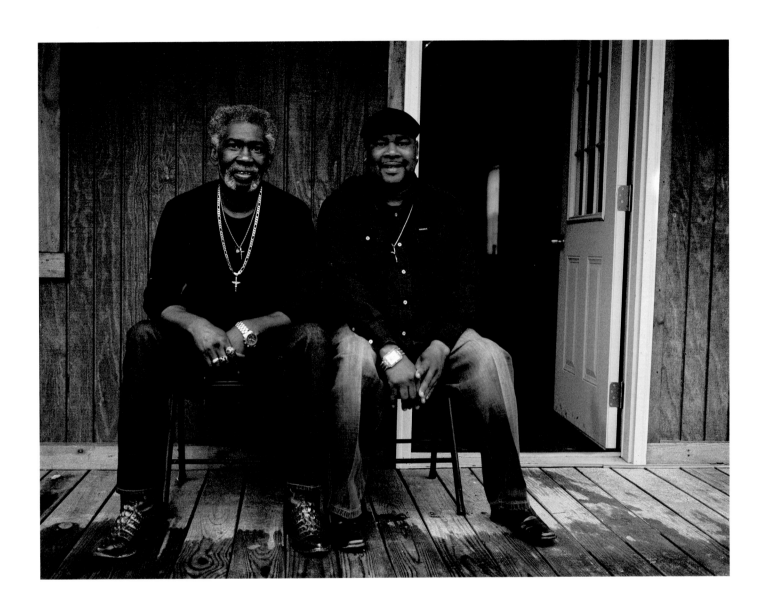

Sometimes in 2012, I came upon a disturbing article about Levon and Kennedy's cases. It stayed with me for months until I contacted the Mississippi Innocence Project, and suggested a photographic documentary around their experience. Levon and Kennedy, their loved ones, deserve to be named, seen and heard. Within rural communities vulnerable to silence and oblivion, they stand witness to wrongful conviction and mass incarceration. IA

This project would not have existed without the generosity of:
Kennedy Brewer, Levon Brooks, and their families.

Tucker Carrington, Director, the George C. Cochran Innocence Project.
Carol Mockbee, Program Director, the George C. Cochran Innocence Project.

Kate Van Houten and Takesada Matsutani, SHOEN Foundation.

Olivier Renaud-Clément.

Special Thanks to:
Craig Cohen, Daniel Frank, Tom Hurley, Damien Saatdjian, Valerie Sullo for their dedication in realizing this book.

And to:
Felicie Balay, Leonardo Drew, Yolanda Fernandez, Dee Vitale-Henle, Jan Henle, Juliette Hoffenberg, Jim Megargee, Luca Michelson for supporting our project.

Printing: Meridian Printing in collaboration with Daniel Frank
Publishing: powerHouse Books
Book design: Damien Saatdjian
Art work: Valerie Sullo, Laumont
Copyediting: Juliette Hoffenberg

Publication of this book is supported by a generous grant from the SHOEN Foundation.

Additional support is provided by the George C. Cochran Innocence Project at the University of Mississippi School of Law.

Levon and Kennedy:
Mississippi Innocence Project

Published in the United States by powerHouse Books, a division of powerHouse Cultural Entertainment, Inc.
32 Adams Street, Brooklyn, NY 11201-1021
telephone 212.604.9074
e-mail: info@powerHouseBooks.com
website: www.powerHouseBooks.com

First edition, 2018

Library of Congress Control Number: 2017957236

ISBN 978-1-57687-884-2

10 9 8 7 6 5 4 3 2 1

Printed and bound in the USA